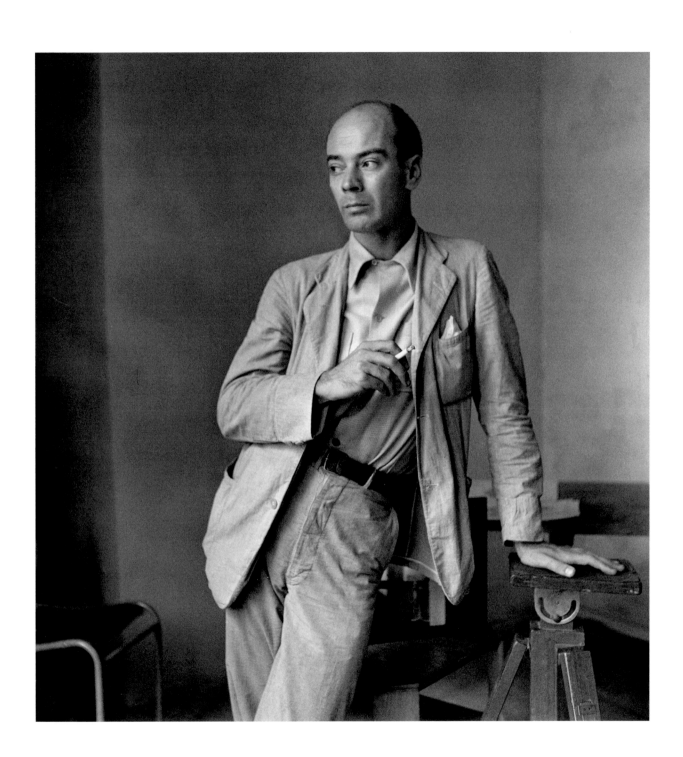

CLIFFORD COFFIN

PHOTOGRAPHS FROM VOGUE
1945 TO 1955

Edited and with a text by Robin Muir

STEWART, TABORI & CHANG
NEW YORK

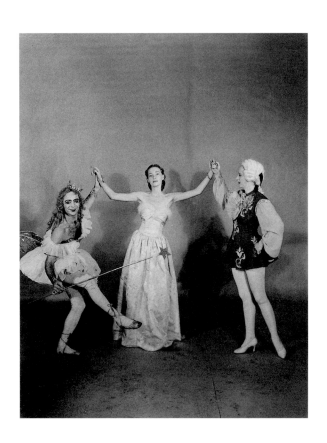

Clifford Coffin, Pat Kenyon and Isobel d'Orthez
London, *c.* October 1947. Unpublished variant from British *Vogue,*
December 1947

*Nothing was too much trouble; in his search for what he wanted
he reduced models to tears, fashion editors to desperation and himself
to complete exhaustion. From the rubble of emotion emerged
a perfect cool picture.*[11]

the varnished truth

The name of photographer Clifford Coffin is well-known to students of the history of fashion and to historians of magazine photography but to few others. To one of the handful that knew him at British *Vogue* he was a photographer way ahead of his time:

"He was the first photographer to actually *think* fashion, sometimes more than the fashion editors. He really knew fashion. No-one has ever felt *Vogue* fashion like he did. He didn't need an editor and he didn't give a damn about anything except his pictures."[1]

He was highly respected by his peers. William Klein, whose wife Janine he photographed in the late 1940s, admired him and Norman Parkinson, not renowned for his generosity towards fellow photographers, admitted that Coffin's fashion photographs (especially his colour work) were the only other *Vogue* pictures he ever really admired.[2]

Many others in the fashion industry can readily identify his most famous images. His portrait of Christian Dior (page 121), for example, one of only a handful to be taken on the eve of his inaugural collection – possibly the only formal portrait – has been widely reproduced; any pictorial survey of 1940s fashion would be incomplete without at least one of his neo-romantic interpretations of the collections of 1948 – they have featured in exhibitions within the last few years in Paris, London, New York and Sydney; a portrait of Matisse towards the end of his life, working in bed on his paper collages (page 74), had particular resonance for the writer Kennedy Fraser, who opened her introduction to an anthology of photographs from the history of American *Vogue* with a description of the sitting:

"I'm glad Matisse is here. Anchored, harmonious this old chap with his tie and his scissors. He is reassuring somehow. So much beneath the perfect surface of these pictures *Vogue* has collected from its archive – fetched up from the image-stream of the twentieth century – seems to quiver with jadedness and pain."[3]

In answer to a request from a gallery magazine for a photograph that had a similar meaning to him Robin Derrick, the current art director of British *Vogue*, offered Coffin's study of Wenda Rogerson in a Rahvis evening gown (page 58). "It is this obsession with the superficial and momentary", he wrote in an accompanying paragraph, "that makes them [fashion photographs] more precise documents of their time than many other more worthy attempts at photo-reportage."[4] Derrick also encouraged, to great effect, a revival of the ring-light in contemporary fashion photography, a type of studio lighting that Coffin first brought to the medium in the mid-1950s. Even as recently as the late 1980s, another of Coffin's photographs (a cover from 1951) reached a different audience as the "flyer" for a London nightclub.

But even within the fashion and magazine worlds, where he spent fourteen years (from 1944 to 1958) photographing for *Glamour* magazine and American, French and British *Vogue* he has remained almost invisible. What has surfaced over the years is often misleading where it is not inaccurate. Even the most basic details are contentious. The facts surrounding his death, for example, were obscured by rumour and counter-rumour. I asked several of those who might have known what happened to him and received conflicting opinions each time: "An accidental overdose of heroin. Definitely heroin killed him", said one; another claimed that he leapt from the top of a New York landmark; "I heard he fell out of a window from an apartment block and X was there and saw it", said someone else; a fourth thought he died in a fire at his studio and yet another thought he had killed himself because his work became out-moded when the 1960s came. That he drank himself to death was the opinion of several, including the photographer Horst. None, it turned out, is correct. His origins were the subject of similar conjecture: "He was Chinese from Chicago"; "definitely half-oriental"; "a half-cast Chicago East-sider"; "Possibly Chinese, probably Eurasian". Isobel d'Orthez, a fashion editor, was convinced he was "half-Italian". Yet another thought he was Indonesian. Gore Vidal who knew him in Paris in the late 1940s believed he was "a relative (but from New England) of Tennessee Williams".

The overwhelming impression was of someone intensely private kicking over his traces and it became apparent that he had done remarkably well. Apart from a sketchy biographical note in 1951, nothing much has been written about him. In 1975, Cecil Beaton, who knew Coffin at *Vogue*'s London studio just after the war, included his photograph of a Schiaparelli ensemble (page 7) in his history of photography *The Magic Image*. Remarking that a source of reference for Coffin's fashion work may have been von Sternberg's films, he found it impossible to find any information on his former colleague and adds little to the biography other than claiming erroneously that both "Louis Faure" (sic) and "the arab Fuelli" – possibly the photographer Fouli Elia – "were influenced, though much more freely, by Coffin".[5]

Unlike many of his contemporaries, Coffin never published books on his work or cared whether they appeared in exhibitions. There is not the market for his fashion pictures today as there exists for his colleagues in the studios of *Vogue* in New York and London, such as Irving Penn, Horst, Beaton, William Klein or Norman Parkinson. Only one of his pictures, the portrait of Christian Dior, has ever appeared in the salerooms.[6]

The history of photography, however, is the history of an incomplete discipline and, of its subdivisions; perhaps the history of fashion photography is the most fragmented. Certainly, it appears to contain an unhealthy number among its practitioners of the rejected, neglected, overlooked and ignored and those who have, for various reasons, allowed themselves to slip from view. Coffin is one of a long list of *Vogue* photographers, for example, who, after early acclaim, disappeared into obscurity. Of course, it is the nature of the business but many of them might sympathise with a howl of anguish from another colleague at American *Vogue*, the photographer Richard Rutledge: "I can't stand America any more", he told Andy Warhol, "I can't stand this fucking fashion world any more. I'm going to kill myself!" Warhol replied "Oh, can I have your watch?"[7]

In 1986 the negatives of Coffin's entire *œuvre* for British *Vogue* were rediscovered in over 350 manilla envelopes, after a locked filing cabinet in an annexe to the *Vogue* library in London was chiselled open. Next to it, another cabinet contained the negatives of the portrait photographer and documentarist of London's Soho John Deakin, whose years with the magazine were, in the words of a studio manager, "blessedly short".[8] Strenuous efforts were made backstage in the studios to keep the two photographers apart for, at first sight, they loathed each other. Coffin, who, according to Isobel d'Orthez had "a great and frightening capacity for self-destruction –

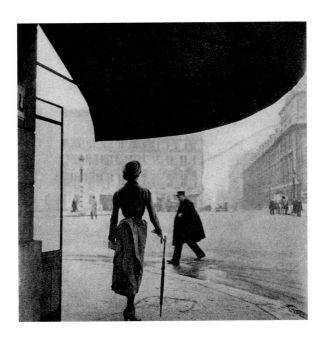

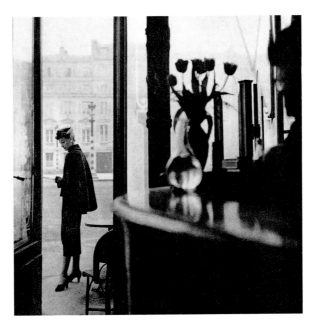

Unknown model
(possibly Anne Moffatt), Paris, February 1948. Fashion: Dior.
American *Vogue*, 15 March 1948, variant from British *Vogue*, 15 April 1948

Wenda Rogerson
(Mrs Norman Parkinson 1923- 87), *model*. Paris, February 1948. Fashion: Schiaparelli.
American *Vogue*, March 1948. French *Vogue*, April 1948

he went missing at St John Roper's farewell party and we found him slumped on top of a rarely-used toilet",[9,] found Deakin's drunken behaviour appalling – much worse than his own; Deakin, in turn, was irritated by Coffin's flaunting of his homosexuality, overwrought self-criticism and fits of exuberance over the minutiæ of *haute couture*. Deakin could not stand fashion photography, which under the terms of his contract he was obliged to carry out, and hated even more the banal exchanges between photographer and fashion editor that Coffin delighted in: "I must have her!"[10] Coffin is reported to have said on first catching sight of the model Barbara Goalen and "I will *not* photograph her in *that hat*", he is reported to have said subsequently at their first sitting together. "Put her in that – she's *tremendous!*" he said to Isobel d'Orthez at his first session with Wenda Rogerson (two years later he refused to speak to her for having married his rival Norman Parkinson).

Perhaps reflecting their opposing attitudes to the medium, the condition of the two photographers' negatives, after forty years, could not have been more different. Where Deakin's negatives were found in a brittle and perilous state, shoved into disintegrating envelopes, Coffin's were meticulously wrapped in tissue paper and painstakingly catalogued in considerable detail: on the reverse of each envelope a handwritten note indicated the date of the sitting, a brief description of the clothes featured and the identity of the model (or sitter if the session was a portrait for the feature pages). It also specified the member of *Vogue*'s staff either in charge of the shoot or responsible for styling it. Several envelopes of Coffin's colour transparencies emerged too; the colours had shifted and paled over the years but not beyond repair, and some contained swatches of material from the garments photographed possibly there to help match up colours during the processing of the film.

One of the *Vogue* librarian's policies in the 1980s was to attempt to reunite photographers with their negatives. There was no indication that Coffin was dead or alive, only an address, a box number in Pasadena, California, scrawled onto a torn scrap of paper and pinned to a tear-sheet discovered in one of the cabinet drawers. The address proved fruitless but the tear-sheet was found to be taken from an issue of British *Vogue* dated 15 October 1966 – a special edition celebrating the magazine's fiftieth anniversary. The full-page photograph was one of Coffin's, a cover shot taken in 1951 of the model Jean Patchett (page 76), whose *soi-disant* beauty typified in the fashion magazines the spirit of the times; he considered it his masterpiece (it appeared in all the international editions of *Vogue*) and the compilers of the retrospective issue clearly agreed, including it as the best depiction of the previous decade's look. The accompanying text was a tribute to the photographer's determination and his *modus operandi* as well as a record of how highly the results were cherished:

> "Coffin was a perfectionist. He could create impeccable elegance from the simplest ingredients; given a couple of yards of striped material he produced a polished professional headdress; given a model and some make up he could make a beauty. He came to *Vogue* from the United States and taught all who worked with him a lesson in dedication. Nothing was too much trouble; in his search for what he wanted he reduced models to tears, fashion editors to desperation and himself to complete exhaustion. From the rubble of emotion emerged a perfect cool picture."[11]

That we know so little about his time at British *Vogue* (despite an archive of prints in excellent condition) is perhaps unsurprising. Photography has not always been considered a respectable way to earn a living and certainly the status of fashion photographers had long been in question. Harry Yoxall, the managing director of British *Vogue* during Coffin's tenure (from February 1946 to February 1948), who entitled a chapter of his autobiography "The Curious Caste of Photographers" and lamented the decline of fashion illustration "while the camera maintains its conquering but boring supremacy",[12] arguably showed more than anyone else that the prevailing attitude came right from the top:

> "For some reason photographers are a peculiarly jealous race. It may be that they subconsciously feel themselves *artistes manqués*; they resent the fact that their medium involves mechanical processes and is not wholly creative; and so an inferiority complex is induced. This trait is exaggerated when, as is not infrequent, the photographers are homosexuals. These suffer morbid suspicions of their colleagues. They claim their

techniques are plagiarized and demand personal assistants restricted to their private use, so that their 'secrets' cannot leak through to other photographers."[13]

However, Coffin's anonymity has much to do also with his own attitude towards commercial photography and *his* perception of his own worth. He had always maintained to friends that one day he would just give it all up and retire to Hawaii. He had no illusions about his rôle. He did not produce art, just photographs for magazines that were looked at once or twice and then discarded, and his expectations were never high. "If I were to name the most interesting assignment I could imagine", he once wrote with perhaps a hint of irony, "I would ask to be given the job of photographing an ash blonde in a white dress in an empty white room."[14]

But there is evidence to suggest that far from just allowing himself to slip discreetly from view when he felt that the time was right he had compelling reasons that made it a necessity, he believed, for his own safety and sanity. Whatever the reasons, nearly half a century after they were printed, the salvaged photographs of Clifford Coffin remain a vivid record of his times. Perhaps to be unaware of his work carefully retained for over four decades by *Vogue* in London and New York, will be seen to betray a shameful ignorance of a distinguished contribution to the cultural scene of the post-war era. And by bringing together his singular vision, in both fashion and portraiture, perhaps fewer fragments of the history of the medium and its commercial application will remain.

★

"Until the arrival of Cecil Beaton and Norman Parkinson", wrote Harry Yoxall, "our London studio was lamentably short of native aptitude; and even when they arrived they were constantly being whisked off to Paris and New York. So we were very dependent on imported talent."[15] Anne Scott-James, a former *Vogue* copywriter and beauty editor, writing in 1952, put it more bluntly: "The fact must be faced that most English colour photography stinks."[16]

British *Vogue* so badly needed a dependable photographer just after the war that its editor-in-chief, Audrey Withers, was despatched in 1945 to the *Vogue* studios, New York, with the sole purpose of signing one up. Coffin was the result of her trip – though she had doubts about him, believing privately that he was the best of a mediocre selection – and he arrived at British *Vogue* at the beginning of February 1946. He was to be shared with French *Vogue*, who had similar problems.

Shortly after his arrival, the entire *Vogue* office decamped from New Bond Street in London's West End to a corner building in Golden Square, Soho. The *Vogue* studios had moved earlier from above a wholesale dental manufacturer at 18 Rathbone Street to larger premises in Shaftesbury Avenue. Harry Yoxall had found it difficult since the 1930s not only to find photographers of a suitable calibre for *Vogue* (and especially those that juggled a skill in portraiture and fashion photography) but to tempt them to the studios at Rathbone Street: "a filthy building... like a deserted warehouse, green walls, huge stairs, badly ventilated and heated".[17] "It was very difficult to work naturally in", remembered one photographer. "The entrance was stacked with false teeth and cases of dental equipment. At the top of the stairs, out of all the dust, rose a portrait of the Queen [Elizabeth, the present Queen Mother]."[18]

The dearth of homegrown talent had continued during the war years; this time most of the *Vogue* studio was engaged in the war effort and many photographers were reluctant to return to shooting fashion after it was over. Norman Parkinson found farming a more fulfilling occupation: "We only get bored away from the country – in London in particular", he wrote.[19] Lee Miller continued the documentary work she had carried out with such success during the war, however, 1946 found her in Hungary and Romania and with no inclination to return to London let alone the *Vogue* studios. Even Cecil Beaton, whose fashion work in the 1930s had almost single-handedly defined the magazine's identity, found it hard to re-acquaint himself with the frivolous world he had left behind for North Africa, India and China as an official war photographer. He was profoundly disillusioned with London life, as can be surmised from a diary entry:

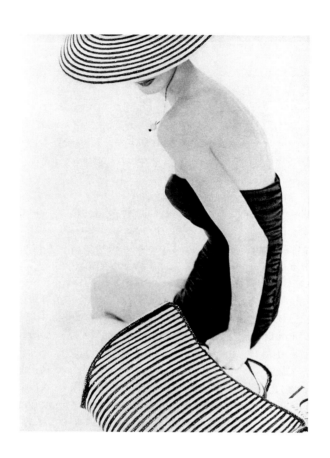

Unknown model
Los Angeles, 1954. Fashion: Tina Leser.
American *Vogue*, June 1954

"Suddenly to me it has become lowering to the spirit. The air seems to have been used up. One is conscious of the untidiness, the discarded bus tickets, the greasy pavements, the look of aimlessness on the faces of those with nothing to do."[20]

Vogue itself had survived the war almost intact, never ceasing publication despite stringent paper rationing, though it cut back from two issues a month to one from October 1939. "*Vogue*", readers were assured, "will continue to be *Vogue* – charming and civilised, a tonic to the eye and to the spirit." It was late on the bookstalls only twice. In fact, Yoxall was able to bring out a new publication in 1940 – the *Vogue Book of Exports* for which special paper rations were allocated by government order. The magazine did not escape the Blitz however – near-hits on Bond Street shattered the office windows and the patterns factory and warehouse in Fetter Lane were destroyed in the last German raid on the City of London.

Against such a background of disenchantment, Coffin's outlook must have appeared refreshingly optimistic: "Confidentially, I am coming over with only one interest to work and to make the best pictures I can", he wrote to Patrick Matthews, the studio manager.[21]

As Yoxall indicated, British *Vogue* had relied on visiting photographers before: Arik Nepo and André Durst had been brought over from Paris in the 1930s and John Rawlings had come from New York in 1936. Rawlings, in particular, had been a great success, developing in Yoxall's words "from a starlet into a star".[22] His experience in London gave him a headstart back in New York where, in a much more competitive climate, he might easily have sunk without trace.

The managing director's faith in another imported American turned out to be well placed; and the quality of the work Coffin produced, especially his fashion photographs, dispelled Audrey Withers' earlier fears to the extent that she was eager to hasten his return from commitments to French *Vogue*: "I am sorry your last visit seemed so hectic ", she wrote barely eighteen months after she hired him, "and especially that I hardly saw you. I do hope you will be over again later in the summer. Please let us know your plans so we can think right ahead."[23] In 1949, when Coffin had returned to New York, Yoxall wrote that he was "entering the magic circle" of "the great names of fashion photography"[24] and again, twenty years after appointing him, wrote that "in succession, John Rawlings and Clifford Coffin came to us as young assistants and returned home as stars..."[25]

To most of the editorial staff in London and to the drab post-war fashion scene Coffin – "the brash American" – was a breath of fresh air. It appears that anyone who met him could not easily forget him – "he was very challenging and very amusing and with a tongue like an asp".[26] His clothes, as much as his behaviour, set him apart from his British contemporaries; Beaton and Parkinson, who conducted their studio sittings with much formality in dress and manners, had the air about them of nineteenth-century *salon* photographers. Even John Deakin wore a suit – albeit crumpled, dandruff-flecked and wine-stained. Coffin caused some disquiet at *Vogue* for photographing Laurence Olivier, Ralph Richardson and Alec Guinness back stage at The Old Vic in casual dress – crumpled flannels and a shirt buttoned up to the neck without a tie (see frontispiece). Despite the less formal atmosphere for which Audery Withers strove, in 1946 it was still considered poor form for her female staff members to turn up to the office without hat and gloves. Harry Yoxall had something to say about this too – some items in the "Yoxall fashion credo" included "every woman looks well in a beret"; "young women should wear white as much as possible"; "nothing sets off an outfit so well as a good pair of gloves".[27] Anne Scott-James considered herself "one of *Vogue*'s half black sheep" because "I often go into Claridges without a hat".[28]

Coffin's flamboyant behaviour did not, predictably, find favour with the managing director. Coffin is the subject of one of Yoxall's anecdotes from "The Curious Caste of Photographers":

"Another [fashion photographer], not the most personable of men, went one day into a fashionable shirt makers in Jermyn Street and asked if they could make him a pair of swimming trunks in the Brigade of Guards colours – 'they're so smart, don't you find?' – the salesman shuddered visibly. 'Oh not for swimming, of course,' the photographer explained, 'just for sun-bathing'."[29]

But from the start, Yoxall had more practical problems with Coffin – *Vogue* was barely able to get him into the country:

"It appeared that there was delay in the issue of his passport because, he told me, his family at some stage had changed their name. 'Surely', I replied, 'they might change their name *from* Coffin but hardly *to* it'."[30]

(Audrey Withers claimed that Coffin and his mother, between them, could not precisely identify where he was born.) Ailsa Garland, a fashion journalist, who some years later would edit *Vogue*, recalled that at the time "Coffin stories were legion":

"A thin, dark nervous character, he was, in his way a genius. He was the first in a long line of interesting and extraordinary photographers with whom I was to work. On one occasion, when coming back from France, he was stopped by the Customs who found a huge bottle of perfume destined for the fashion editor. Pulling out the stopper from the bottle he splashed himself and the customs officer liberally with the scent. 'I always use it, don't you?' Men then only used a little discreet after-shave lotion."[31]

Coffin enjoyed dressing up in the clothes and accessories called in for his fashion shoots. There are several pictures taken backstage at the studio to support this (pages 15, 144). Snapshots taken at his farewell party in 1948 reveal a saturnalia in progress, with several of the studio staff and photographic assistants, increasingly the worse for alcohol, in full drag. The most startling of all, now existing only as a poor quality photocopy, shows Coffin dressed as a Swiss maid in long pigtails and made up with thick false eyelashes and "cupid's bow" lips. Accompanying him, with false teeth and a moustache, the late Patrick Matthews, *Vogue*'s studio manager does an especially precise impersonation of Harry Yoxall. The inscription on the reverse sums up studio life: "Larking about. Why? No-one knows – it was a fun place to work in." In the Christmas issue of *Vogue* for 1947 Coffin even made it into print in drag (pages 4, 31). Audrey Withers ran his Christmas *tableau*, an homage to the Englishness of pantomime and the gender reversals crucial to its humour: the model Pat Kenyon played Cinderella, Isobel d'Orthez was Prince Charming and Coffin, wired up to the studio ceiling, took on the rôle of the Fairy Godmother. "What a change it is", he wrote in the accompanying text, "to dangle from a rope instead of a chandelier."[32] He was, however, an unconvincing Santa Claus at American *Vogue*'s Christmas party of 1949. Slumped against a wall among festive detritus, head lolling to one side, he was photographed for the Condé Nast staff magazine with the accompanying understatement: "1.30. . . and Santa's had a hard day!"[33]

It became apparent that, where Coffin was concerned, anything at all might be possible; and the more absurd the stories that spread about his behaviour the more they were believed by his startled colleagues. One contemporary, for instance, was convinced – mistakenly – that Coffin had been exiled to London against his will "for some misdemeanour in the United States".[34] According to the *Vogue* contributor Don Honeyman the photographers were often forced to work at a ridiculously fast pace and tempers frayed behind the scenes. Deakin was fired twice by *Vogue* for a series of drunken, ill-tempered incidents; and the gentlemanly Norman Parkinson, when riled, bit into his transparencies and tore them in half with his teeth; Beaton fumed at being "most useful to them [*Vogue*] as a photographer who can flatter old women and so they give me all the difficult jobs. . . " Coffin's behaviour, according to some accounts, took a more sinister turn. Denis Whelan, who knew Coffin in the art room of *Vogue* in the 1950s, found him "inclined to melancholy in the extreme, always crying. . . He had periods of intense depression, almost paranoid" and, more incredibly, had a "very un-British way of behaving, specially when he hit the models."[35]

Isobel d'Orthez, one of his many champions, found herself justifying his outbursts of temper: "He knew how to get the best out of a woman, even if it meant tantrums and recriminations."[36] Others like the model and fashion editor Patricia Cunningham found him in tears more often than his supposed victims. By contrast, another fashion editor strove to avoid working with him wherever possible:

"He was very tough to work with – beastly to the girls. So insulting, so rude. Very unpleasant. He reduced models to floods of tears. He could not work with them unless they were putty in his hands and only then could he get good pictures."[37]

The model Anne Gunning shunned him for similar reasons. He so insulted a young fashion assistant that Gunning herself became "a gibbering wreck. I just could not work with that man".[38] But to Anne Moffat, one of the models for his 1948 collections, "he was sweet and kind and I loved him".[39]

Conduct that would be considered unremarkable at fashion shoots today was unheard of in 1946. Coffin's behaviour was considered "erratic" when he developed a penchant for stone walls as backgrounds and took a team to Colchester where, on a weekend away, he had seen one that attracted him.[40] On another occasion he caused an incident by accosting the Dean of Westminster Abbey, splendidly attired on his way to evensong, and attempted to link him hand in hand with a model – "it *is* for *Vogue*". Appalled, the Dean did not actually refuse to pose but "just annihilated Coffin, sweeping through the party as if they were invisible. 'How different it is with you British', he said".[41]

This episode appears lightly disguised in a piece of contemporary fiction, Anne Scott-James' *In the Mink* (1952). Her excitable photographer Barbar appears to be many parts Coffin:

"[Barbar] would spot amusing little scenes and incidents that he wanted to work into the pictures. He wanted the sentries at Buckingham Palace to come out of their boxes and be snapped with their arms round the models' waists. He thought the English 'so stuffee' when it proved hard to arrange. Then he saw Mr Neville Chamberlain walking into the House of Commons, and wanted to stop him and work him into a spring hat photograph. He was charmed at the sight of three bishops talking in the street outside a bookshop and wanted to put a girl in a skunk coat in the middle. I had a go for this hoping they might be sporting parsons who would be amused to oblige; but they were not."[42]

His *folie de grandeur* reached its height when a fashion editor on location realised that he was screaming with rage not at her but at Stonehenge, which, after a long journey in a convoy of Rolls-Royces he felt "should have been very much larger".[43] It had been his dream to photograph there: "Never have I been able to get it out of my mind – a summery evening dress, light in colour, at that terrifically aged monument which represents England's eternity. Oh I *do* wish we could."[44]

In Paris his conduct raised fewer eyebrows in the fashion room of *Vogue* – the magazine had employed many volatile photographers in the recent past – and the editors were less reserved than their British counterparts in curbing Coffin's outbursts. Despina Messinesi recalled that in a chauffeur-driven car heading towards a sitting with a distinguished Parisian, Coffin became increasingly agitated, disapproving of the subject to be photographed. "So I had the driver stop in the middle of the afternoon traffic on the Champs-Elysées and told Coffin to step out. He did and we cancelled the sitting."[45] Simone Eyrard, who worked in the Paris studio found him "a curious personality!" She added that "as far as I was concerned he was a sick man". She rescued him from the scene of another incident. When the authorities at the Gare St Lazare refused his request to halt the passenger train called the *Flêche d'Or* before it pulled into the station, so that a few shots could be taken on the platform, Eyrard recalls that he "had a nervous crisis".[46]

A few weeks later any sympathy for him evaporated forever:

"Coffin made a terrible fuss about my darkroom boys, who were true specialists and with whom we worked wonders when, during the flow of the collections, we lived under impossible pressures. We were in the darkroom and he raged out of control. Patience deserted me and I locked him in this room where I left him for a good hour. I went back to find him as calm and sweet as could be."[47]

Others, like Janine Klein, wife of the *Vogue* photographer William Klein, admired him – "he was the only photographer who wasn't pretentious and certainly never 'difficult'"[48] – and Thelma Sweetingburgh the veteran fashion editor of French *Vogue* found him hilarious company:

"He declared he wanted to photograph some summer clothes along the banks of the Seine towards St Cloud in the Bois de Boulogne. We were all delighted with the prospect of a walk under the trees along the river. Once there, Coffin led us on and scrutinizing the water in silence, he suddenly stopped. There was a lump – quite a large one – just under the surface. He turned to the model saying, 'I wonder if you would put your foot on this...' The girl approached, took one look and shrieked. The lump was the bloated corpse of an animal – the rotting carcass of a medium-sized dog."[49]

Sitters took to him as well. The designer Piero Fornasetti, photographed in Rome in 1946, was delighted with the results of his session with him. "The isle of elegance created by Coffin", he wrote gushingly, "seems to me like a rock in a Zen garden."[50] As his moods swung, the stories grew more outlandish. "It was an era", remarked *Glamour* art director Bruce Knight, "of so many mad people with Cecil Beaton at one end of the see-saw and Coffin, on edge, at the other." He added that:

"Coffin should have lived in the sixties. He was very wild and totally before his time. He was so rude and treated the editors so badly. He used to phone up Edna Chase [American *Vogue*'s matriarchal editor appointed in 1914] and tell her dirty stories and once he photographed the youthful son of a senior – and haughty – *Vogue* staff member with his trousers round his ankles. The mother never forgave him."[51]

★

Coffin's early life was the subject of much conjecture by those that knew him and he was skilful at deflecting enquiries into his background. He was deliberately vague about his date of birth and his antecedents, giving out only the briefest *resumé* of his career to those that asked. So many wild stories sprung up around Coffin that it is hard to separate him from popular perceptions of who he was and where he might have come from – and there is every indication that he relished these misleading tales. Without embroidering them, he did little – if anything at all – to clear the air. The truth is, of course, much more prosaic than his contemporaries might have hoped and his lineage more distinguished than he ever admitted.

He was born on 18 June 1913 in Illinois, one of the ninth generation of a family that could trace its history back to an early settler in the New World, Tristram Coffin. Clifford's father, Clifford Leon Coffin and his mother Ruth Pullen, grew up together in a farming community near Salem, Illinois. Clifford senior's parents, Albert and Florence Coffin were Quakers and considered "cultivated, smart and well-read people for their day".[52]

In fact the Coffin family can trace its roots much farther back than the seventeenth century to one Sir Richard Coffin from Falaise in Normandy, who invaded England with William the Conqueror and was rewarded with the county of Devon for his allegiance to William after the latter's accession to the English throne. A branch of the family, the Pine-Coffins, still live in Devon at the ancestral estate Portledge Manor at Alwington, near Bideford, towards the North coast of the county.

Tristram Coffin, at the age of thirty-seven, left his estates and emigrated to the New World in 1642 from the parish of Brixton near Plymouth. He settled first in Salisbury and Newbury, Massachusetts but later, along with Thomas Macy and Captain Edward Starbuck and others, he bought Nantucket Island from the native indians and the Coffin family in the United States moved there in 1659. A distinguished Quaker family, it celebrated its 350th anniversary in the New World in 1992. The descendants of Tristram have shone in many walks of life. Apart from providing a president of the Metropolitan Museum of Art, the founder of General Electric Company as well as head of the underground railroad during the Civil War, there have been among their number, distinguished jurors and authors, explorers and poets, meteorologists and philanthropists, bankers and architects. As seafarers they must

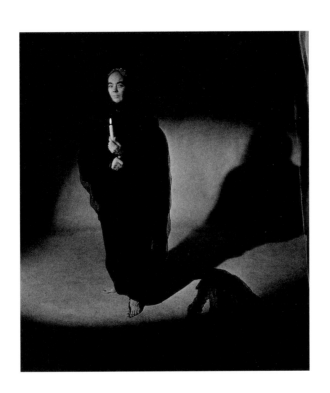

Clifford Coffin
London, c.1946.
Unpublished self-portrait

surely have an unparalleled record: over one hundred ships' captains, including four British admirals, at least four naval commanders in the U.S. fleet and one Coffin, a civilian, who saved the U.S. fleet from destruction. It is also recorded that over one hundred Coffins lost their lives at sea over the last three centuries. Clifford junior was proud of his ancestry, though he failed to attend any large public gatherings of the clan (for example one in Nantucket in 1959 which attracted over five hundred members of the family). However, he had a gold ring made by Cartier, the jeweller, engraved with the family crest.

Clifford Coffin's father, Clifford senior, had a variety of occupations, but his working life was spent mostly as a travelling salesman – he worked for an undertaker in Centralia, Illinois, and sold salt for the Martha Salt Company but would always rejoin his family at weekends and for holidays at their farm, though he had no inclination to till the land like his ancestors. Taking a job as a salesman for a silk manufacturer in 1922, the family moved to Pasadena, California, when Clifford junior was nine years old. His grandfather William H. Clifford lived there. There Clifford senior decided to start up on his own, travelling to Italy to buy silk, which he then "finished" and sold to the undertaking industry. Clifford junior accompanied him on several of his buying trips to Europe and at an early age was exposed to the beauty of Paris and Rome. Later he would tell Patrick Matthews: "For certain if I ever had any surplus time it would be spent in Italy."[53]

Ruth Pullen, Coffin's mother, "was always very fashionable and well put together, spending time on her appearance", remembered her nephew Dwight. "Clifford as a boy used to try on all her clothes and jewellery and spent more time in front of the mirror than his sister Frances."[54]

He also accompanied his mother as many as three afternoons a week to the movie theatres. "Hollywood and being so close to it, I'm sure, was a strong influence", recalled Dwight, "Clifford loved the movie lot and going to watch pictures and films being made and, of course, anything to do with stars. I mean, he was right in the middle of it. In the twenties and thirties the movies were extravagant."[55]

Coffin graduated from Pasadena High School and took some courses at the art institute, Pasadena, which did not include photography. Although Clifford junior had other interests, his father insisted that he prepare himself for a career in business and he graduated in finance around 1935 from the University of California, Los Angeles (UCLA). Throughout his life he was an astute businessman, adept at managing his stock portfolio and in later years he liked to watch its movement on the ticker-tape in his broker's office.

The painter Buffie Johnson, a freshman at UCLA, wondered how she was going to cope with "these awful people" at college but met Coffin and "his beautiful sister and we became firm friends. I was a treat for him and he for me – so unlike the others[56]. Coffin financed his studies by taking a job as a night clerk at a small hotel and Johnson helped him out with contacts in the art and magazine worlds, including Frank Crowninshield at *Vanity Fair* (which merged with *Vogue* shortly after Coffin's graduation) and Ann Jones, fashion editor of *Town and Country*.

After leaving UCLA, Coffin continued in the hotel trade at the front desk and then decided on a career in accounting. He had other jobs in Los Angeles: at an advertising agency and in the film business for MGM. In 1938 or 1939 he arrived in New York and took up a post as a financial analyst for Texaco, the oil company. He was lonely in the city and, with time on his hands, he decided that he would become a photographer – even with no formal training – and that *Vogue* magazine was the best place to start. He greatly admired its standard of photography. Buying himself a cheap camera, he shot a few rolls of film, put together a makeshift portfolio and made an appointment to see one of the art room staff. His cousin Dwight recalled what happened next:

"Obviously Clifford was young, naïve and bold enough to show him the little portfolio and he reported that the art editor [possibly Alexander Liberman] treated him very graciously and gave him a few tips, for example, to buy himself a new camera and to concentrate on one subject – cityscapes of New York. He told him to come back and see him in six months. He did and the editor was impressed and gave him another assignment and to come back in six months. Again he came back again and the art editor told him he was definitely improving and to come back again in six months. This continued until the war started. Many photographers were being drafted into the armed forces and so Clifford was given the chance to work at *Vogue* on a trial base for three months at no salary."[57]

With enough money saved up from his job at Texaco he took up the offer. Sometime during one of those six month periods, or while he worked in the studio, he managed to attend some photographic classes, possibly at the suggestion of the art editor. These classes were run by George Platt Lynes, at that time one of New York's most admired photographers, and who would exert a profound influence on Coffin's work.

Coffin met Lynes around 1940. The latter had a thriving studio at 604 Madison Avenue and was in demand not only by the Condé Nast magazines such as *Vogue* and *Glamour* but by a range of corporate clients including the fashion stores Henri Bendel and Bergdorf Goodman. His classes were small and informal and held in his studio after working hours. Elizabeth Gibbons, who would later work with Coffin as a *Vogue* fashion editor, recalled meeting him for the first time at one of them:

"I was the model for one of his classes in the studio where students observed him demonstrating his way of working. George always asked me to pose at night as a favour for this group of maybe twenty would-bes. I remember Coffin with his meaningful looks at both me and George ... who couldn't take it. I do remember that."[58]

Lynes' success as a photographer seemed effortless; even in the most rigorous of his client-led briefs there is something, most often a semi-Surrealist edge, that distinguishes his campaigns from those of his rivals. His fashion pictures were poorly received, though, by many of his contemporaries, such as his friend Cecil Beaton, "his work in this field now reveals his lack of interest and appears wooden, imitative and often ridiculous".[59]

Lynes loathed his fashion work too and destroyed much of it before his death in 1955 though he proved that, for a while, he was amongst the medium's best practitioners. He could switch styles with ease: from tightly controlled and specifically lit studio shots to informal daylight portraits *en plein air*. This was a tip that did not pass Coffin by. For all of his professional life Coffin was dexterous inside and outside the studio with what ever equipment he came across. Several times in different locations in Italy on a week long assignment for *Vogue*, Coffin had to borrow unsuitable half-plate cameras when his brace of favourite Rolleiflexes failed him.[60] The twin lens Rolleiflex with its low angle and ground-glass viewfinder was by far his favourite camera (both in and out of the studio) suiting him as the Leica did Cartier-Bresson and a generation of documentarists. It is perhaps worth noting Anne Scott-James on the subject: "... any fool can get a passable picture on a Rolleiflex, though few can produce anything of real merit".[61]

Where Coffin strove to immerse himself in the world of fashion, Lynes tried to cut himself free from it. He had had a remarkable early career as photographer (and writer) in Paris like so many of his compatriots. Forming close friendships with Jean Cocteau, Pavel Tchelitchew and Gertrude Stein (he makes an appearance in her *Autobiography of Alice B. Toklas*), he was a prominent member of the city's *avant-garde* and later exhibited with Walker Evans at the Julien Levy Gallery in New York. Much of the income from his fashion commissions financed his private studies of the male nude, which, along with his documentary work with the American Ballet (now the New York City Ballet), are undeniably his finest achievements. He considered his nudes the culmination of his life's work and in the five years before his death much was bought by Dr Alfred C. Kinsey for his eponymous Institute at Indiana State University. As in so much of his *œuvre*, he demonstrated extraordinary versatility with his nude work. Some are experimental abstracts, some daylit and natural, some are highly stylised and others over-worked to the point of kitsch.

Coffin too considered his own male nudes (almost all now destroyed) as his finest work. It is unlikely that Coffin knew much about Lynes' photographs since the latter was wary of mentioning them, even obliquely, outside a small circle of friends and sympathisers but it is interesting to discover that in terms of the composition and lighting of frontal nudity and the homoerotic context that Coffin's series appears to imitate at least one of Lynes' styles.

Most of them were taken in front of a neutral backdrop and the results printed up to thirty inches in height. It is perfectly possible (and indeed likely) that both were working on their portfolios in isolation – Coffin was terrified of any of his studies falling into the wrong hands too – but the two photographers, tutor and pupil, may well have kept in touch when Lynes was appointed head of *Vogue*'s Hollywood studio. Coffin's work for the magazine would

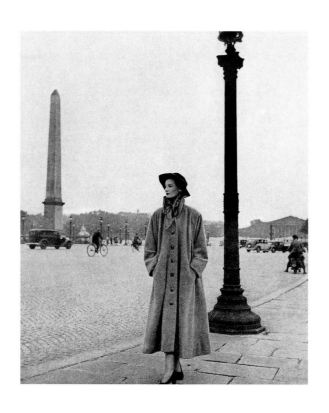 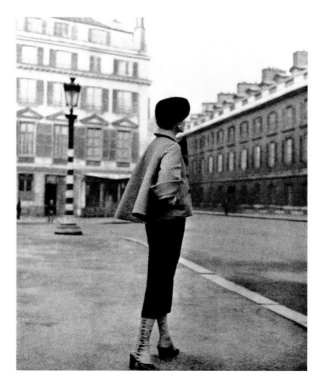

Wenda Rogerson
(Mrs Norman Parkinson 1923-87),
model. Paris, February 1948. Fashion: Griffe.
French *Vogue* April 1948

Unknown model
Paris, February 1948. Fashion: Dior.
American *Vogue,* March 1948.
French *Vogue,* April 1948

often take him to Los Angeles, where his fashion editor would invariably be Lynes' friend and Pasadena resident Liz Gibbons. Lynes' photographs for the American Ballet, with whom he collaborated from 1935 till his death twenty years later, would certainly not have gone unnoticed by Coffin. His cousin Dwight recalled that as a child, Coffin's first ambition was to be a dancer:

"He loved the ballet but his father refused to allow him to become a ballet dancer. His mother and sister were also interested in ballet too and he went with his sister to her lessons. But his father said absolutely not...He [Coffin] always felt that he would have been a good dancer as he had the physique and moved like a cat. Extremely graceful."[62]

In New York he greatly admired George Balanchine. "I don't know that he attended the ballet very often but it was one of his great interests and he loved that abstract style of ballet. He loved the sheer movement."[63]

<p style="text-align:center">★</p>

Coffin's first photographs for American *Vogue*, from 1944 to 1945 were mostly awkward and undistinguished studio portraits of minor musicians, dancers, actors and other second tier celebrities of the era and all with few exceptions were reproduced at a very small size in the magazine.

Though he was in London for barely two years before being assigned to the Paris office, by contrast, his output for British *Vogue* was extraordinarily high, rivalling the productivity rate of another staff photographer John Deakin. Between the two they dominated the magazine in 1947 and 1948. While Deakin's fashion work shone on only rare occasions, tending mostly towards the mediocre, Coffin's was of a strikingly high standard. In barely two years, from April 1946 to April 1948, he organised 364 fashion shoots and portrait sittings, one on average every second day, for *Vogue*, the *Vogue Knitting Book*, the *Vogue Book of Exports*, the *Vogue Beauty Book*, the *Vogue Pattern Book* as well as many cover tries for *Vogue* and interiors shoots for *House and Garden*. He was for a while in 1947 almost single-handedly keeping the magazine creatively alive. For the June issue, for example, he shot forty-nine photographs – three times the number of jobs assigned to anyone else. Each sitting demanded enormous preparation, whether in the studio or on location, and a constant stream of new ideas and other conceptual considerations. Unlike most photographers – certainly the British ones – Coffin took an interest in every detail of his working life, becoming as obssessed with, for example, his models' make-up and clothes as he was with every creative aspect of his sittings. He left nothing to chance. Traditionally, models did their own make-up but Coffin often had his own ideas. According to the late *Vogue* model Wilhelmina:

"You were afraid to disagree with him, and you never let him get close to you under any circumstances because, as he was so creative with make-up, you weren't going to walk out of his studio looking the way you came in. He thought only of the picture he was going to take, and when it came out it was sensational. You looked like a different girl, but he ruined you for three weeks; nobody else bought you from what they saw in that picture, and nor would he. The following week he wouldn't want you that way. Having plucked all your eyebrows out and drawn strange and wonderful images on your face he would say 'Who plucked those eyebrows out!'"[64]

He always did his models' hair himself in the era before star hairdressers and he invariably scraped it out of sight or hid it with a hat. "I told him", wrote Ailsa Garland, "that future readers, looking through old magazines, would think that the women of Britain in the late forties were bald."[65]

Coffin appeared to push himself too much. Even as early as August 1945, *Glamour* magazine recognised his determination. "[He] has no hobbies", it told readers, "since his chief hobby, photography, has turned into a highly successful profession."[66] At British *Vogue* there was an effort behind the scenes by Patrick Matthews to relieve his workload by directing fashion assignments elsewhere, mostly to photographers like Deakin who proved inept

at carrying them out. Coffin acknowledged that the rigorous discipline he learnt in London was a habit, which even years later he found almost impossible to break:

"It seems as if I am usually unhappy most of the time (frustrated, neurotic) ... I find I have no social life any more, spending practically every night in my darkroom (I have living quarters in my studio) working away making prints and developing negatives endlessly. Also I finally gave up alcohol completely because I couldn't do darkroom work expertly with hangovers."[67]

His early fashion shoots for *Vogue* relied to a large extent on the pioneering efforts of others, most notably Cecil Beaton. Although making infrequent visits to the studio, he lent the newcomer the benefit of his experience in the fashion world as well as more practical things, for example, his cloth backdrops and at one point his assistant, Dick Dunn, whom he had tended to guard jealously. When Coffin became successful very quickly the free advice dried up, though Dunn's services were retained. Coffin repaid the debt with flattering imitations of Beaton's style. Certain motifs and compositional devices used by Coffin can be found in the pre-war work of Beaton, though he strove never to treat his sittings purely as exercises in style. Peter Brook, for example, surrounded by crumpled paper and leaning on studio props is as formally arranged as one of Beaton's pellucid debutantes a decade earlier (page 116). "He didn't just take my picture as I had expected", remembered Brook, "but draped me in seemingly endless streamers. Yards and yards of white paper. He would pause for a while, smile, look dissatisfied, then excitedly add another layer."[68]

Some images from his collections of 1948 are pointedly semi-Surreal, a hybrid of Beaton's stylised dream landscapes and the harder-edged, purer Surrealism of George Platt Lynes. Nancy Hall-Duncan in her *History of Fashion Photography* placed Coffin firmly with Beaton and Lynes in her chapter "Surrealism and Fantasy", pointing out:

"A ... dramatic desolation, as well as as a sense of impending horror is implied in a work by Clifford Coffin. In this picture [page 27] nothing is *happening*, yet there is a sense of imminent catastrophe and vacuous horror which presages the work of Guy Bourdin in the seventies."[69]

Though perhaps put a little strongly, there is a discernible flirtation with Surrealism to which Coffin would frequently return throughout his career – with various degrees of success. One of the better examples is page 79. His last sitting for British *Vogue*, was another attempt at an eye-catching *tableau*, a hyper-real depiction of "jewel coloured" evening dresses. Slow shutter-speed exposures of moving models resulted in a series of blurred and distorted abstracts which were considered too inventive for the magazine and were quietly "killed". Under firmer art direction such an eye-catching sequence would have received a prominent position in the magazine's fashion pages. Such devices and tricks were part of the kaleidoscope that made William Klein's photographs for American *Vogue* (under the guidance of art director Alexander Liberman) so impressive and influential in the 1950s. Though he would never have seen these photographs Klein was no stranger to Coffin's work. According to the writer Martin Harrison, though Klein "had admired Clifford Coffin's photographs of Janine Klein, his wife, he made no attempt to emulate Coffin's approach, which concentrated on qualities intrinsic to fashion".[70] Though Coffin's career would last another eight years or so, he was never invited to work for British *Vogue* again.

Coffin left London for Paris in 1948. He had already made frequent visits to the city, not least to photograph the collections in February and July 1948. He finally moved there in October 1948. Moving between the Hotel Lotti and the Pont Royal Hotel, he threw himself into expatriate life and struck up friendships with the writers Truman Capote (page 102), who had just published his first novel *Other Voices Other Rooms* and Gore Vidal (page 96). He photographed the latter on the left bank under the Pont Royal. Vidal remembered him as "bald sardonic. As a photographer he was blessedly quick. I was living at the Hôtel de l'Université, he was somewhere around the rue de Bac."[71] Writing years later, he recalled that "Coffin preferred natural light, so we spent a morning on the left bank of the Seine, waiting for the right light to come off the river".[72]

Parisian life suited him and he found French *Vogue* rewarding employers, though according to one staff

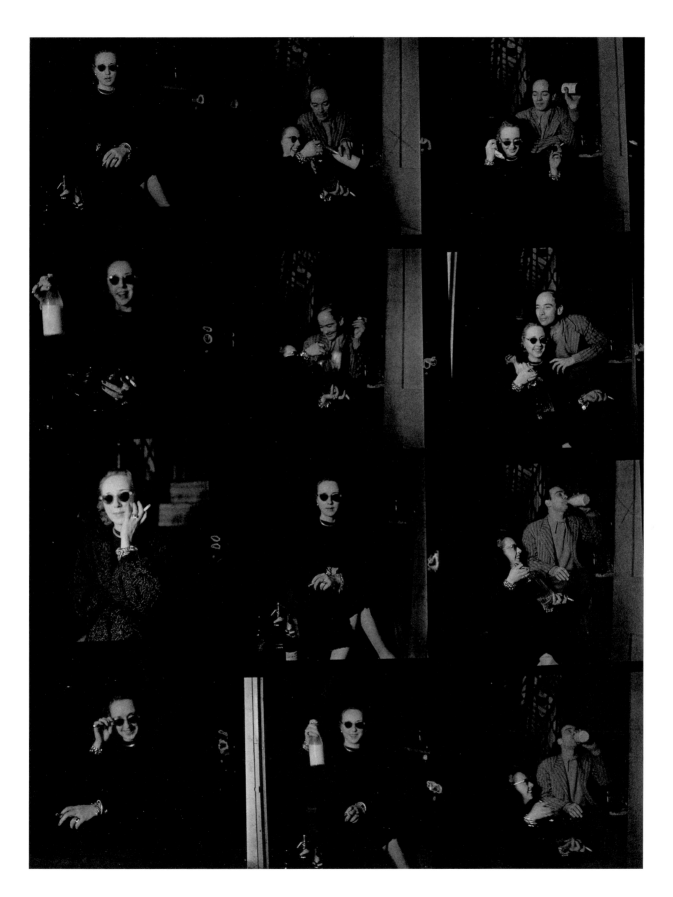

Clifford Coffin and Isobel d'Orthez
Vogue studio, London, *c.* 1947. Unpublished contact sheet.
Photographer unknown

member "there was a crisis everyday"[73] and he appeared to make few friends at the magazine. Edmonde Charles-Roux, who supervised practically every celebrity photo-shoot can remember very little about him because "his sessions were mostly conducted in silence".[74] However the magazine gave free rein to his love of dance and he was able to photograph among others Leslie Caron of the Ballet de Champs-Elysées (page 93) and André Eglevesky. He was also asked to provide scenes from artistic life in Paris for British and American *Vogue* and was an unofficial editor-at-large for the former, bombarding Audrey Withers with ideas.

With the excitement surrounding Dior's "New Look", Paris started to regain its pre-eminence in the fashion world and Coffin patently revelled in his position at the centre of it all. Ultimately Withers believed that Coffin grew to "loathe the English and [our] models even more, finding us uninteresting and unattractive as a race. He found rationing unbelievable!"[75] His series of collections in 1948 , a highly stylised and romantic evocation of *fin-de-siècle* Paris, was a perfect foil to the bleakness of the times. The sheer extravagance of the "New Look" found a natural supporter in Coffin and underpinned his photographic style for the rest of the decade. A contemporaneous account of another American's visit to the city is worth recounting. Jane Hutchinson, a young prizewinner of the Prix de Paris, *Vogue*'s contest for aspiring writers, accompanied Coffin to his couture sittings and for *Ink*, the Condé Nast staff magazine, provides a first-hand description of the Paris he attempted to conjure up in his photographs, a sensibility to which she was so evidently attuned:

"There is a different sense of time in Paris … It is a time that belongs to another century, another world. Leisure and elegance linger on behind the high walls and carriage doors of great mansions … in the exquisitely panelled 18th-century drawing rooms … in the symetrical gardens, the statue-studded squares and broad boulevards … it is a time that feels the weight and wear of other centuries. One sees creamy, crumbling plaster walls that stump down to narrow cobblestone streets...the so soft shadings of buildings, bridges, statues, water, air, played one against the other … the battered beauty of Paris … the delicate patina and pallor of all Paris."[76]

Hutchinson also had a practical bent :

"I tried to be an extra pair of hands or legs or a size 23 waistline . . . Three collections a day were hyphenated by business lunches, dinners. Night long vigils were spent photographing collecton highlights and cabling collection news. And then...in the wake of sweat and sleeplessness I tasted the overwhelming thrill of seeing first proof on finished pages...afterwards parties took over where work left off..."

Coffin evidently relished the bursts of creative activity: "I have a bitch of a head cold...but am so happy and content in Paris", he wrote to Withers. "Must be spring fever but I don't think I've ever felt more *sustained* happiness in my life."[77]

At the end of 1949 he was recalled to New York and for most of the next decade worked for American *Vogue*. It was not creatively his best period. He was not given many of the prestigious fashion assignments. Instead, he was asked to do much department store fashion along the lines of "For Vogue's Young Nil-lionaires" and "An American Marvel – Great Clothes at Good Prices". It was, in fact, a fallow period for many of his colleagues too. Jessica Daves replaced Edna Woolman Chase as editor-in-chief in 1952 and in the words of Horst's biographer, Valentine Lawford:

"Her taste in fashion was as conservative as that of her predecessor; but in Horst's view she lacked Mrs Chase's ability to understand and encourage her more imaginative subordinates, including photographers... although his relations with Miss Daves had been – and would continue to be – conventionally correct and even cordial, he found her artistically uninspiring."[78]

In his diaries, Beaton put it with characteristic bluntness: "Their present editor [Daves] suffocates my enthusiasm".[79]

Coffin's work suddenly looked outmoded, especially the neo-Romantic *tableaux* that British *Vogue* admired so much. And though his career with the Condé Nast group of magazines would last for the next decade, it is probably true to say that his best work was now behind him, though, in all fairness, the influence he would have on the next generation of photographers stems precisely from this period in New York. But he was certainly never again given the creative freedom he enjoyed in London and Paris. His American *Vogue* work was not considered first-rate by his contemporaries. In fact its very ordinariness appeared to be its strength. Rosamond Bernier chose him to photograph Matisse "precisely because of his anonymous quality. I did not want someone who would assert his personality and make demands".[80] As Alexander Liberman's biographers have shrewdly noted, Liberman needed a range of more pedestrian work by, among others, Coffin to let the witty and incongruous fashion images of William Klein, for example, shine more brightly: "a little Klein", they wrote, "went a long way in *Vogue*."[81]

Liberman, however, was quick to praise Coffin's work too. In a letter to Audrey Withers, he wrote: "He [Coffin] has been doing some remarkable work and if you look back, his French reports were amongst our best".[82]

His autumn couture series of 1954 was perhaps the greatest achievement of his later career. American *Vogue* ran forty-eight of his pictures in their collections issue, British *Vogue* thirty-five and French *Vogue* forty-five – an extraordinary number even for the biggest issue in a fashion magazine's year.

They were remarkable too for a lighting technique, the ring-light, that Coffin brought to fashion photography (the hallmark he believed of a great photographer was to develop a style of lighting identifiably his own) and which successive generations of photographers, including David Bailey and Helmut Newton in the 1960s and 1970s and Nick Knight and Juergen Teller more recently, would modify, refine and use in their own distinct ways. The ring-light, a ring of eight tungsten photofloods welded to a tripod through which the lens of the camera was pointed, had been adapted by Coffin from its primary use which had been for scientific purposes. Ideal for fine detail work in difficult situations, it was especially valued in cosmetic dentistry as it resulted in a perfectly even light from all angles with no shadow distortion. Coffin's adaptation was large, about three feet or so in diameter and mounted on wheels. It gave his photographs the distinctive look he hoped for.

The halation of shadow cast around the sitter had been pioneered by early twentieth-century portraitists using an early version of the ring-light as a "fill-in" – an accessory light, which illuminated the shadow cast by the main light source. The Pictorialist photographers used another version of it to cast a fine line around their high-key nudes, perhaps to render their images nearer to painting by imitating an artist's etching lines.

No-one used it to such success in the commercial world as Coffin did and its impact was profound on his fellow photographers and art directors. Beaton returned Coffin's admiration of a decade earlier by imitating the ring-light effect for a portrait of Deborah Kerr, barely two issues after Coffin unveiled his discovery. Advertisers and fashion designers loved it too for the obvious reason that it gave a superb degree of clarity to their products, bleaching out unwanted creases and blemishes.

His cover for the Christmas issue of American and British *Vogue* (December 1954), his Autumn collections pictures of 1954 and a series of pictures "Spring Red" from February 1955 show his mastery of the ring-light and earned him and his art directors, Liberman and Priscilla Peck, American Art Directors' Club awards in 1955.

As the light worked best close-up it all but blinded the models and the heat generated was tremendous, on a par with two electric fires – "like working through a stove", remembered one contemporary.[83] In some instances it led to distortion of the image and disconcerting "catch-lights" in his sitters' eyes. According to Helmut Newton, who years later with Guy Bourdin re-discovered Coffin's light abandoned in a cupboard at the *Vogue* studios in Paris, it was "a big heavy metal and wooden affair, about a meter in diameter, which held about ten photoflood bulbs. The light quality was beautiful, the only drawback being the heat produced by 5000W of electricity and the fact that it was hard to move around." He used an electronic version enabling him to "take pictures from a distance of three to four meters, a minimum necessary for fashion work".[84]

David Bailey also acknowledged his debt in an interview with writer Carol di Grappa:

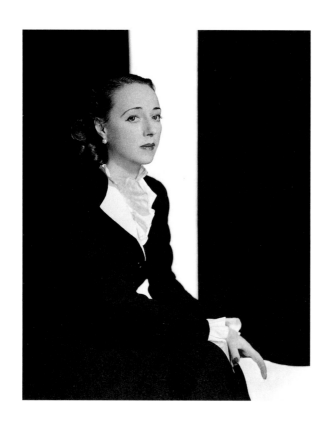

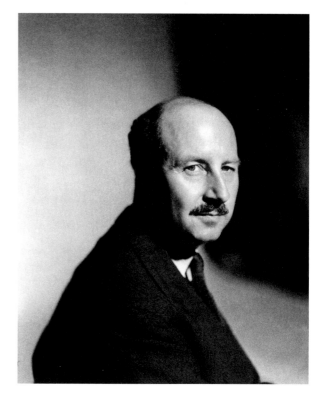

Isobel d'Orthez
fashion editor, London, *c*.1947.
Unpublished photograph for British *Vogue*

Harry Yoxall
(1896-1984), *Managing Director* of
British *Vogue*, London, 18 July 1947.
Unpublished private commission

"Both the *Wedding Photograph* and the *Horizontal Nude of Marie* were made with an Olympus and a ring-light. The ring-light eliminates shadows except for the fine black line around the figure. Since 1961 I've used this adaptation by Clifford Coffin of a light dentists use to photograph inside mouths.

My original ring-light was incandscent. I got terrible burns on my forehead from looking through the fucking thing. When the strobe ring-light came along, it took me ages to figure out how to get rid of the red eye."[85]

In the same interview Bailey also lent insight into Coffin which few others have attempted to do:

"Coffin had a homosexual view of women as untouchably elegant. The best fashion photographers have a homosexual attitude that's something remembered from one's mother."[86]

Stories about Coffin continued to abound. On a trip to Cuba with the fashion editor Babs Simpson and the model Jean Patchett to photograph Ernest Hemingway in 1950 (page 73) he found a character stronger than his own and for once was unable to dominate the sitting. It is famously recounted by Kennedy Fraser in *On the Edge*:

"They [Simpson, Patchett and Coffin] found an apparently abandoned house littered with half-filled champagne glasses, but then Hemingway finally appeared with a drinking companion, a priest who immediately attached himself to Simpson. Hemingway's hostility towards *Vogue* cooled considerably after he met Patchett ... She perches warily at the end of the couch under his predatory gaze. 'It was a very sweaty situation', Simpson recalls."[87]

In fact, the picture used is a miracle of photographic printing, being a seamless composite of two negatives, one where Patchett looks at her least stunned and the other of Hemingway at his most attentive.

One of Coffin's great strengths was his acute awareness of what it took to be a great model and he launched several fledgling careers. The thrill of discovering a new model and watching her reputation soar on the back of his published pictures was irresistible. More than one colleague has suggested that his reputation should rest not on his fashion work but his superb beauty pictures: "A versatile genius, he could light a face better than anyone",[88] wrote one commentator. "He was terribly inventive", said another. "He could make anyone look beautiful. He did his own make-up and hair. In those days there was so much more input by the photographer on the whole look."[89]

Ailsa Garland paid tribute to his discerning eye in her memoirs:

"He was a true creative fashion photographer, one of those who adds so much to the fashion scene. He would see a girl in a café or on a bus and go up to her and in his American drawl say, 'Would you like to be in *Vogue*?' After she had weighed him up and realised that this was not an amorous approach, she usually agreed to come for a trial sitting and in nearly every case he had found a new face. One girl he met in a night club had started life in a circus being fired out of a cannon – he made her look like a Duchess."[90]

Audrey Hepburn was one of these famous discoveries, though he had apparently passed her over at least once on the grounds that she was too fat. He tested and worked with Wenda Rogerson first, though Beaton discovered her as an actress at a provincial theatre. He made her wear a plaster cake on her head. Patricia Cunningham, who as Patricia Creed would become one of British *Vogue*'s most influential fashion editors, met Coffin for a modelling test on the same day as Rogerson and became a firm favourite for hat shots. He requested Barbara Goalen on many occasions and encouraged the impeccably groomed *hauteur* which became her hallmark. The fashion editor Bettina Ballard recalled another discovery in her memoirs:

"It was Elsa Martinelli, crouching like a trapped animal ... She spoke not a word of anything but Italian and was terrified to find herself in an unknown city ... Clifford Coffin took beautiful pictures of this Etruscan beauty, which made a top mannequin of her the moment they appeared and also helped her toward the far more glamorous career of a successful actress."[91]

They had to be, according to Joan Morton of the *Vogue* studios, "unbelievably thin. He used to make them bang their hips in unison against the flimsy hardboard walls of the studio to reduce them"[92] and as another contemporary noted he was not above "nagging them into taking thyroid pills and uppers to keep them slim. He was a perfectionist but with dubious methods."[93] Though this is scarcely credible, it does illustrate Coffin's exacting standards. He pushed himself hard and expected the same commitment to perfect pictures from all around him. And he could be "exceptionally thoughtless, telling them they looked dreadful".[94]

<p style="text-align:center">★</p>

Early on in his career Coffin outlined his goal – to accumulate enough wealth to retire on (allegedly $250,000) – and towards the end of the 1950s he was on his way to achieving it, thanks to the number of advertising accounts he managed to secure. In 1954 in a letter to Audrey Withers he was blunt about his ambition: "...and besides the pleasure of working with you again, dear friends, I also would like to earn as much money as I can."[95] Patrick Matthews was prevailed upon to find as many commercial assignments as he could: "I know that J. Walter Thompson has a London branch but I am eager to do any fashion work whatever, so feel free to quote anything pricewise that is mutually profitable."[96]

When the *Vogue* studios closed down in 1951, he operated first out of his home on East 19th Street before opening his studio on three floors at 170 Lexington Avenue, close to the city's fashion merchandising district. He was extraordinarily successful. Harry Yoxall credited Coffin, along with John Rawlings as "...the first to turn fashion photography into big business".[97]

By the mid-1960s, Coffin was able to stop photographing altogether (his last pictures appeared in *Harper's Bazaar* in February and April 1961) and by the time his cousin Dwight met him in 1964 he was working part-time as a librarian at the New York University in Washington Square. He had another reason for giving up. He could not control a drug habit, which his lifestyle had fostered since the late forties. He was a habitual user of LSD and other milder hallucinogens, which he said helped him creatively. "It was just marvellous," he admitted to his cousin. "I loved LSD but it was just not good for me."[98] He also admitted that he was often completely out of control and became afraid for his sanity. It is most likely that this accounts for the maniacal behaviour that most of his colleagues associate with him: the bizarre, obsessive habits, the mood swings and the "immediate and unreasonable dislike"[99] he took to many people including the photographer Frances McLaughlin-Gill, which had her worried for her safety. "Sometimes he'd speak to you, other times he'd ignore you. You just never knew what would happen next",[100] remembered another contemporary. He was also obsessively thin and often subsisted on nothing more than cups of black coffee, six bottles of beer and a supply of cigarettes.

There were less contentious reasons for stopping as the new decade opened. His style began to look dated; his delight in the opulence of 1950s couture was at odds with the youth-orientated fashions of the period; make-up artists, hair stylists and fashion editors resisted his hands-on approach; he had put his physical and mental health at risk and he was incapable of prolonging his staying power by calling in favours. Dwight Coffin has put it succinctly:

"He was a loner and a recluse in some ways and was a person who sought adulation. He remembered with pleasure the actresses, the models and all the other people he had met but he was not a 'networker'."[101]

A driving force in his life was his homosexuality. He was forthright about it and there is little doubt that it contributed to his "maverick" status. As his cousin remembers:

"He was a very upfront homosexual all his life and the minute he met anyone – your grandmother, your mother, your daughter – he would let you know he was homosexual. He got that right out. It was shocking even for New York in the sixties. I would say Clifford was the most truthful person I have ever known. There was no pretence. What you saw was what you got."[102]

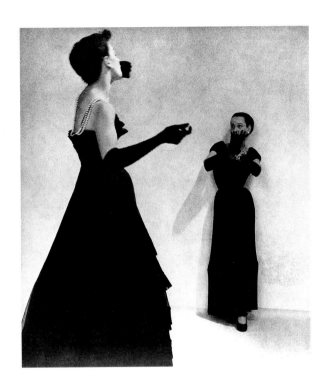

Unknown models
Paris, April 1948. Fashion: (left) Heim, (right) Piguet.
French *Vogue,* May 1948

His honest, though confrontational, attitude made him socially unacceptable to many. One colleague maintains, with a hint of regret, that she "didn't encourage Coffin's re-acquaintance. I had two young sons I was protective of anyway."[103] But for all those that gave him up there were many more open-minded friends like Mary Jane Russell, one of his favourite models, who enjoyed his company. So did the art director of *Glamour* Bruce Knight: "he was witty, bitchy and for the dull fifties, shocking – imaginatively so".[104] The fashion editor Melanie Miller liked him too:

"He would like to shock you and showing your sitting photographs in the darkroom he would turn over a photo of porn he might have taken the day before. Once you said 'that wasn't our sitting was it?' he got the message and was wonderful."[105]

He finally decided to quit New York in the autumn of 1965. He had come back to the Lexington Avenue studio – where he also lived – to find the interior burnt and charred to the other walls. Police manned the front door which had been taken completely off its hinges. The ground and first floors were gutted and the photographs he had kept there – his entire life's work (except his *Vogue* pictures) was in ruins. It was evidently an arson attack preceded by burglary. His plans chests of prints and drawers of negatives had been systematically ransacked before being set on fire. Dwight Coffin helped him to salvage the remains with little success:

"Photographs were strewn everywhere, all over the floor in smoke and water. We had to wear raincoats and boots in there for two days. We tried to pick up some of them and put them in the garden to dry but it was useless."[106]

Much of his collection of male nudes was missing which rendered him "hysterical for six weeks".[107] And with good reason. Those whom he photographed were either friends or others with whom he had had casual sex and had consented to having their picture taken on the understanding that the results were for him only and would never be divulged. Many of the willing participants were actors and several became Hollywood stars and household names. "I am certain", remembers Dwight Coffin, "that Coffin believed that the missing photographs had been stolen to order and that the threat of blackmail was likely to hang over him – or his sitters – for the forseeable future."[108] Coffin himself appeared in many of the pictures and, of course, as they tended towards graphic depictions of arousal and sexual participation he was open to prosecution:

"I remember the photographs ... I'd never seen anything like them. I was bowled over. I knew he was a homosexual but to see these pictures! I helped Clifford pick up the damaged and ruined photographs and negatives that were left because we had to get rid of it quickly. Man police and firemen had been in the house already. He was scared to death that he was going to be prosecuted and he was very afraid of blackmail ..."[109]

The fire finished off whatever was left of him as a photographer. He immediately decided to leave New York and put the house up for sale before cleaning or renovating it. And he told no-one that he was leaving. "Friends of mine knew him", said Bruce Knight, "lived right across the street from him and they never knew what happened to him. He just disappeared. You just don't know what happens sometimes ..."[110] Buffie Johnson, his friend from college days said that "he stopped phoning and I never saw him again. We didn't fall out. I think he was just not himself."[111]

His intention was always to spend the rest of his life on the beaches of Hawaii but he did not get there. Stopping off in Pasadena to visit his dying father, he never left. He found that his own health was beginning to fail. He confided later to a library clerk, Mrs George Pyle, while she was checking out his books, that he would like to go to Hawaii as that was where he hoped to die.

Towards the end of his life he lived in a simple room in the Pasadena Young Men's Christian Association (YMCA). He was, incidentally, a committed aetheist. A librarian at the Pasadena Public Library, a Mrs Baxter, told

a colleague that she knew "he was quite ill and that he seemed to be a very lonely man. She told him one day that she had prayers said at her church for him. He thanked her but mentioned he had no faith in prayers."[112] Elizabeth Gibbons, who saw him occasionally on his retirement, remembered his arrival:

"[Coffin] was sure that someone was after him. This was a very real terror for him. He would have no telephone, called me from pay phones and lived in careful anonymity he claimed."

"How much was paranoia?" she added. "God knows he had his share of that."[113]

His last known address was East California Boulevard and before that the Pasadena Athletic Club and his correspondence address was presumably a box number (P.O. Box 558, Pasadena, California 91102) found two decades later in the archives of British *Vogue*.

He died aged fifty-eight in the Huntingdon Memorial Hospital in the early hours of 2 March 1972 of throat cancer, for which he bravely refused surgery. He was cremated a week later. His will, published the following month, revealed that he wanted "his remains [to] be buried in the Pacific Ocean without embalmment".

He left one-third of his estate to The Lighthouse, an association for the blind in New York because his eyes had enabled him to find satisfaction in his career as a photographer; one-third to the Pasadena Public Library "for the purchase of books dealing with all phases of the fine and creative arts excepting music" and one-third to the YMCA of Pasadena for, among other purposes, "the purchase of a suitable number of Magnavox television sets ... subscriptions to the *Pasadena Star-News* and *Los Angeles Herald Examiner* and the purchase of living plants for the lobbies and dormitory floors ..." (He had had some trouble with the YMCA before his death, according to his lawyer, but the bequest remained in his will).

The local newspaper, the *Pasadena Star-News* carried the headline "Library Gets Funds from Coffin Estate" which revealed that the bequest to the Pasadena Public Library was worth $113,881.81.[114] A bookplate for each item purchased was to be specially commissioned as a means of providing a continuing acknowledgement of Coffin's benevolence. "This was a wonderful, generous act of Mr Coffin ... and I mentally thanked him many times",[115] said one of the librarians, several of whom became his friends towards the end.

"I laugh about trying to normalise him for posterity", wrote Gibbons, "when he tried so hard to make the most lurid impression."[116] And perhaps that is not a bad way to be remembered at all.

It seems fitting that the *éminence grise* behind Coffin's best work, the art director of British *Vogue*, John Parsons – as nervous and sensitive as the photographer he commissioned so much from – should have the final word. Coffin found in Parsons a sympathetic ear for his troubles and a mentor who pushed hard for the inclusion of his photographs to the bewilderment of much of the *Vogue* staff. By all accounts, Parsons fitted in as uneasily as Coffinin the world of *Vogue* with its unfamiliar codes of conduct.

As a team they produced some of the most memorable fashion photographs in British *Vogue*'s history, certainly the most accomplished in the immediate post-war era. Parsons illustrated an article "Fashion in Fashion Photography" with photographs by Coffin, among others, and it seems inconceivable that he did not have him in mind when he wrote:

"Looking back through old issues of fashion magazines we may, according to our dispositions, snigger, sneer, guffaw, shed a patronizing or loving tear for the antics of our own or (according to age) someone else's youth. Whatever our dispositions or our age, we are all sometimes held entranced for a while by some moment of beauty held in existence for ever by the magic of the camera and the artistry of the man behind it. These are great photographs: great because they were taken by photographers who, perhaps, only momentarily had the quality of greatness in them. There may not be many photographs of this calibre, but they do exist; their beauty undiminished by the passing of time ..."[117]

Notes

1 Joan Morton, interview with author, November 1986
2 Vivien Hamley, conversation with author, September 1996
3 Kennedy Fraser (intro.), *On the Edge: Images from 100 Years of Vogue* (Random House, New York 1992), p. 2
4 *Great 7*, The Photographers' Gallery, London July/August 1996
5 Cecil Beaton & Gail Buckland, *The Magic Image* (Weidenfeld & Nicolson Ltd, London 1975), p. 281
6 Lot 119, *The Collection of Pierre Le-Tan*, Sotheby's, London, October 1995
7 Victor Bockris, *Warhol* (Muller, London 1989), p. 126
8 Patrick Matthews, interview with author, June 1986
9 Vicomtesse d'Orthez, interview with author, August 1986
10 Morton, op. cit.
11 British *Vogue,* 15 October 1966, p. 87 (author uncredited)
12 Harry Yoxall, *A Fashion of Life* (Heinemann, London 1966), p. 78
13 op. cit., p. 106
14 Alexander Liberman (ed.), *The Art & Technique of Color Photography* (Simon & Schuster, New York 1951), p. 68
15 Yoxall, op. cit., p. 103
16 Anne Scott-James, *In the Mink* (Michael Joseph, London 1952), p. 127
17 Morton, op. cit.
18 Don Honeyman, interview with author, October 1986
19 Quoted in Martin Harrison, *Parkinson* (Conran Octopus, London 1994), Chapter 4
20 Cecil Beaton, *Diaries: The Happy Years* 1944-1948 (Weidenfeld & Nicolson Ltd, London 1972), p. 51
21 Clifford Coffin (CC), undated letter to Patrick Matthews (PM)

22 Harry Yoxall, *Penrose Annual* 43 (1949), p. 68
23 Audrey Withers (AW), letter to CC, 5 May 1948
24 Yoxall, *Penrose*, op. cit.
25 Yoxall, *A Fashion of Life,* op. cit., p. 104
26 Bruce Knight, interview with author, March 1987
27 Yoxall, op. cit., p. 106
28 Anne Scott-James, *The Condé Nast Publications Today and Yesterday*, 1958
29 Yoxall, op. cit., p. 104
30 Yoxall, op. cit., p. 104
31 Ailsa Garland, *Lion's Share* (Michael Joseph, London 1970), p. 41
32 British *Vogue,* December 1947, p. 57
33 Condé Nast, *Ink* No. 19, March 1950
34 Denis Whelan, interview with author, 1986
35 op. cit.
36 d'Orthez, op. cit.
37 Isobel Tisdall, interview with author, September 1986
38 Lady Nutting, interview with author, 1986
39 Anne Chapman, letter to author, January 1987
40 Rosemary Cooper, letter to author, 17 August 1986
41 op. cit.
42 Scott-James, op. cit., p. 58
43 Cooper, op. cit.
44 CC, letter to AW, 10 March 1948
45 Despina Messinesi, letter to author, 5 September 1996
46 Simone Eyrard, letter to author, 23 July 1996
47 op. cit.
48 Janine Klein, letter to author, 10 August 1996
49 Thelma Sweetingburgh, letter to author, 18 June 1996
50 Piero Fornasetti, letter to author, 14 January 1987
51 Knight, op. cit.
52 Interview with Dwight Coffin, 9 October 1996
53 CC, letter to PM, 9 July 1954
54 Dwight Coffin, op. cit.
55 op. cit.

56 Buffie Johnson, interview with author, 11 October 1996
57 Dwight Coffin, op. cit.
58 Elizabeth Gibbons, letter to author, 17 March 1987
59 Cecil Beaton, *The Magic Image,* op. cit., p. 230
60 July 1946
61 Scott-James, *In the Mink,* op. cit., p. 126
62 Dwight Coffin, op. cit.
63 op. cit.
64 Quoted in Charles Castle, *Model Girl* (David & Charles, London 1977), p. 156
65 Garland, op. cit., p. 42
66 *Glamour,* August 1945, p. 93
67 CC, letter to AW, 9 July 1954
68 Peter Brook, letter to author, 7 December 1986
69 Nancy Hall-Duncan, *The History of Fashion Photography* (Alpine, New York 1979), p. 106
70 Martin Harrison (afterword), William Klein, *In and Out of Fashion* (Jonathan Cape, London 1994), p. 251
71 Gore Vidal, letter to author, 1986
72 Gore Vidal, *Palimpsest: A Memoir* (André Deutsch, London 1995), p. 168
73 Eyrard, op. cit.
74 Edmonde Charles-Roux, letter to author, 3 July 1996
75 Withers, op. cit.
76 Condé Nast, *Ink* No. 11, August 1948, pp. 6-9
77 CC, letter to AW, 10 March 1948
78 Valentine Lawford, *Horst* (Viking, New York 1985), p. 309
79 op. cit.
80 Rosamond Bernier, letter to author, 21 June 1996
81 Dodie Kazanjian & Calvin Tomkins, *Alex: The Life of Alexander Liberman* (Knopf, New York 1993), p. 204
82 Alexander Liberman, letter to AW, 26 April 1954
83 Ray Williams, interview with author, 1986

84 Helmut Newton *World Without Men* (Schirmer/Mosel, Munich 1993), p. 30
85 Carol di Grappa (ed.), *Fashion Theory* (Lustrum Press, New York 1980), p. 11
86 op. cit.
87 Fraser, op. cit.
88 Jean-Noël Liaut, *Modèles et Mannequins* (Editions Fillipacchi 1994), p. 96
89 Knight, op. cit.
90 Garland, op. cit.
91 Bettina Ballard, *In My Fashion* (Secker & Warburg, London 1960), p. 267
92 Morton, op. cit.
93 Honeyman, op. cit.
94 Morton, op. cit.
95 CC, letter to AW, 9 July 1954
96 CC, letter to PM, 9 July 1954
97 Yoxall, *A Fashion of Life,* op. cit., p. 104
98 Dwight Coffin, op. cit.
99 Frances McLaughlin-Gill, letter to author, 16 February 1987
100 Knight, op. cit.
101 Dwight Coffin, op. cit.
102 op. cit.
103 Gibbons, op. cit.
104 Knight, op. cit.
105 Melanie Miller, letter to author, 12 September 1996
106 Dwight Coffin, op. cit.
107 op. cit.
108 op. cit.
109 op. cit.
110 Knight, op. cit.
111 Johnson, op. cit.
112 Josephine Pletscher, letter to author, 24 June 1988
113 Gibbons, op. cit.
114 26 October 1973
115 Pletscher, op. cit.
116 Gibbons, op. cit.
117 John Parsons, *Penrose Annual* 49 (1955), pp. 73-5

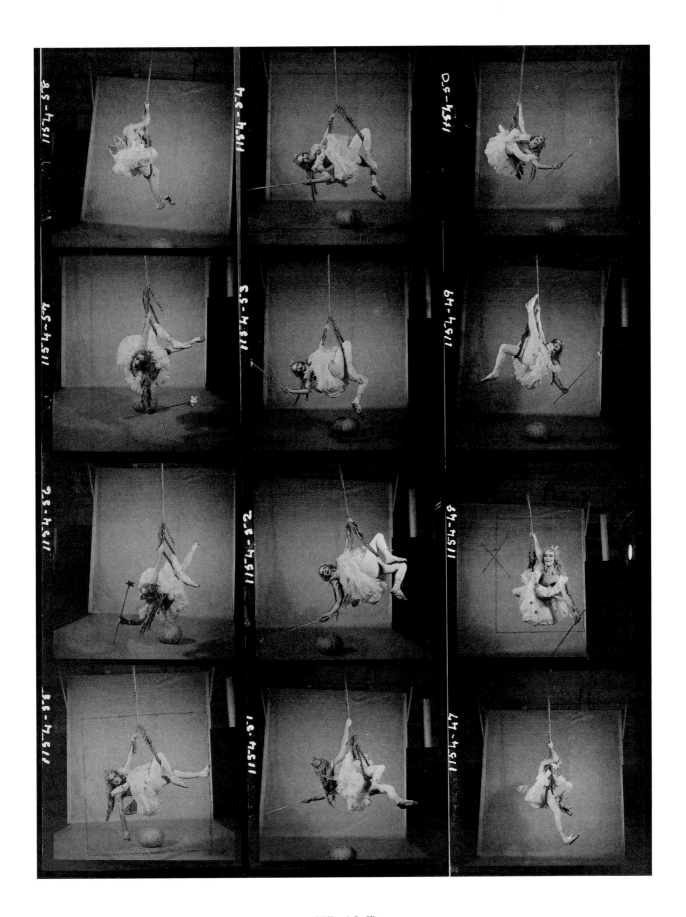

Clifford Coffin
London, *c.* October 1947. Unpublished variant from British *Vogue,*
December 1947. Photographer unknown

plates

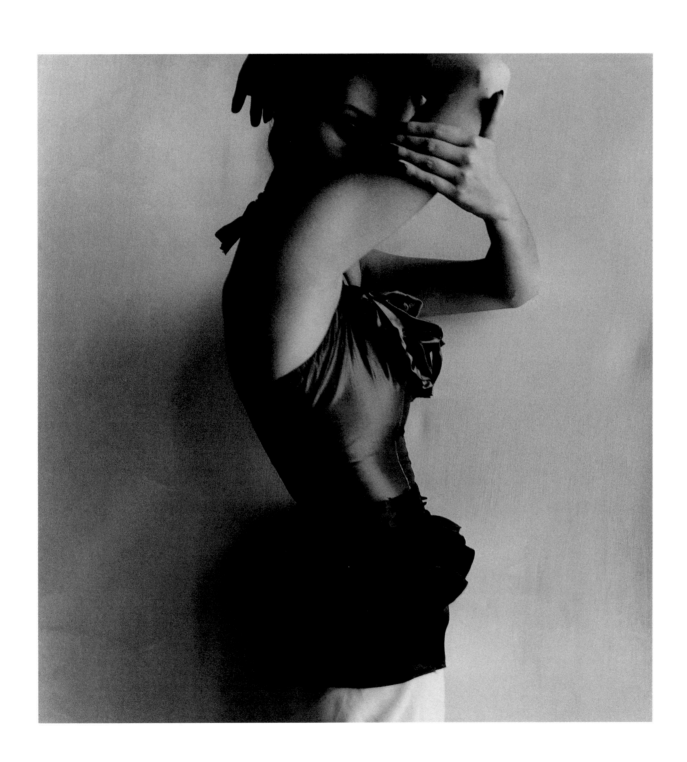

Unknown model, 1946

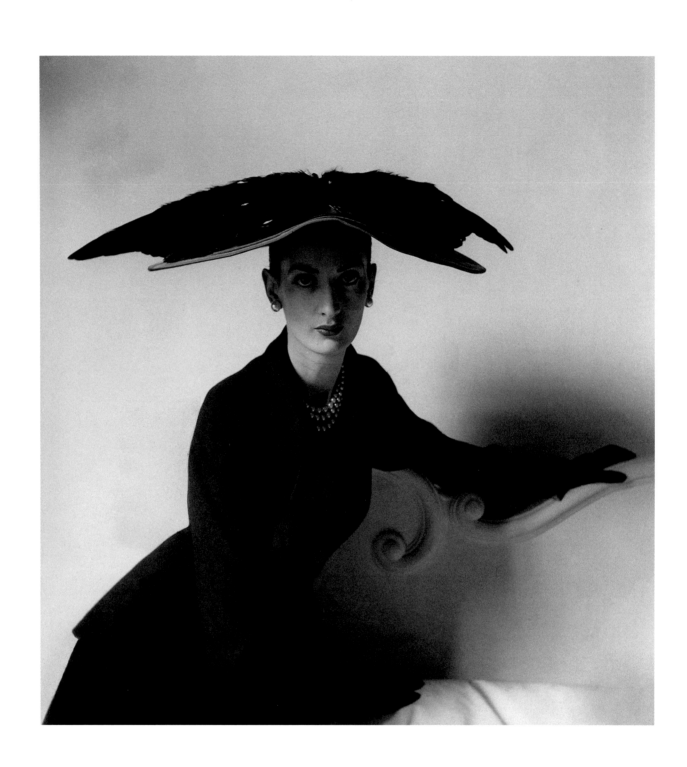

Unknown model, 1948

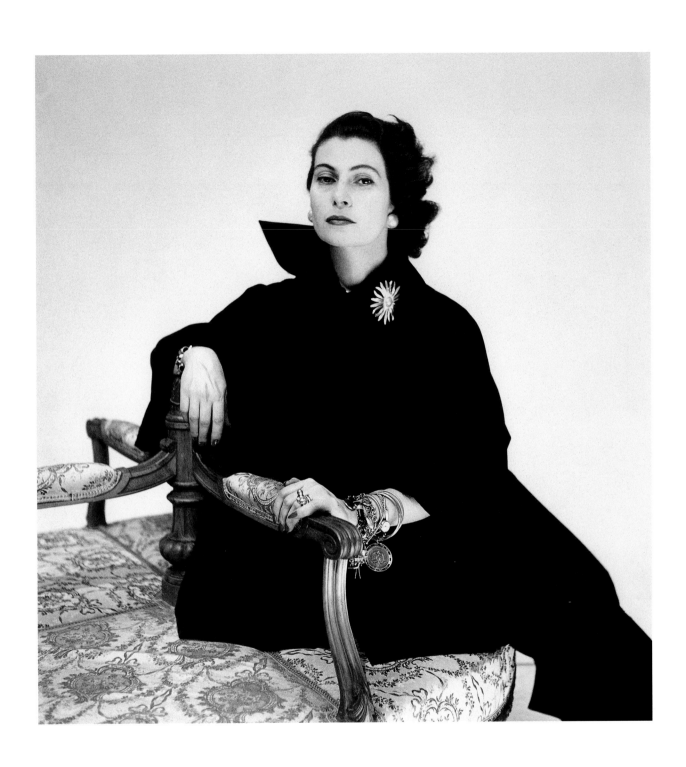

Donna Simonetta Colonna di Cesaro, 1951

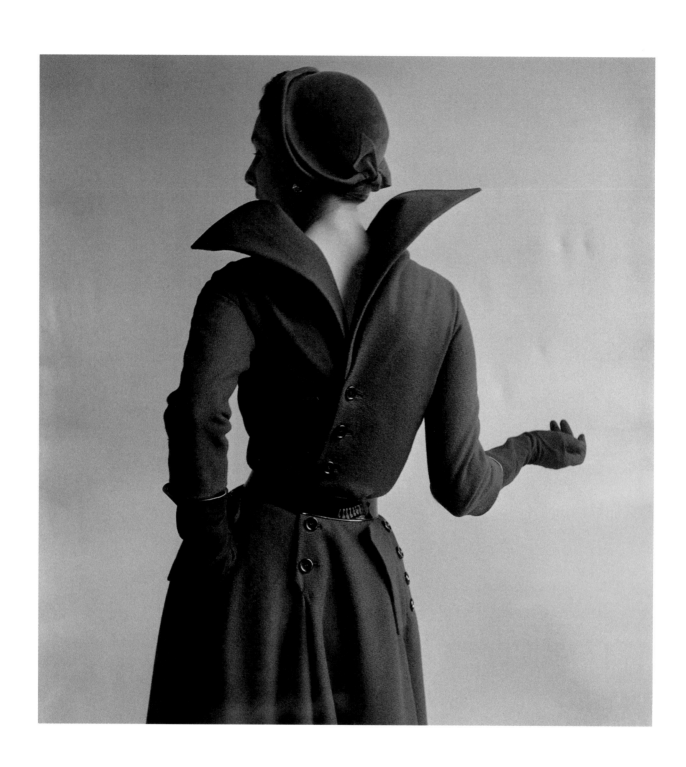

Barbara Goalen, 1948

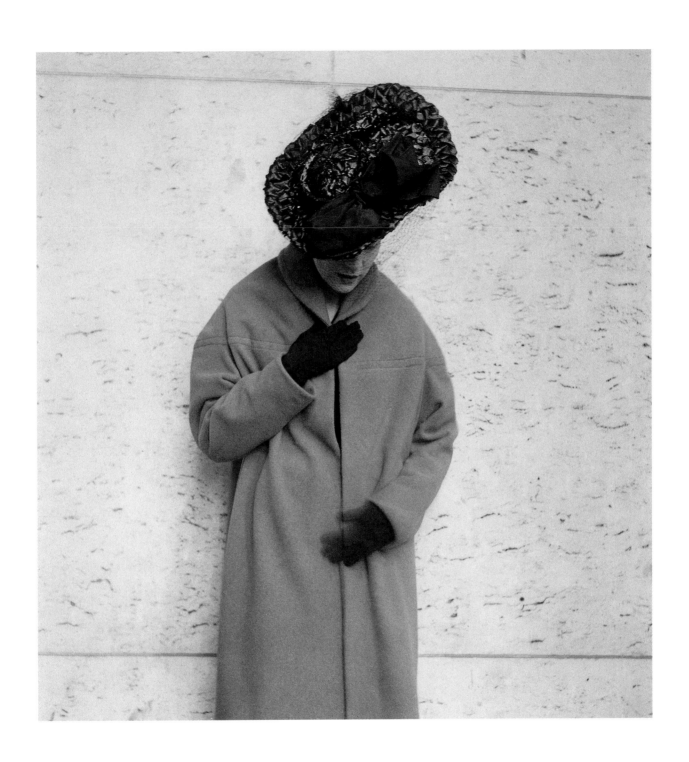

Unknown model, 1948

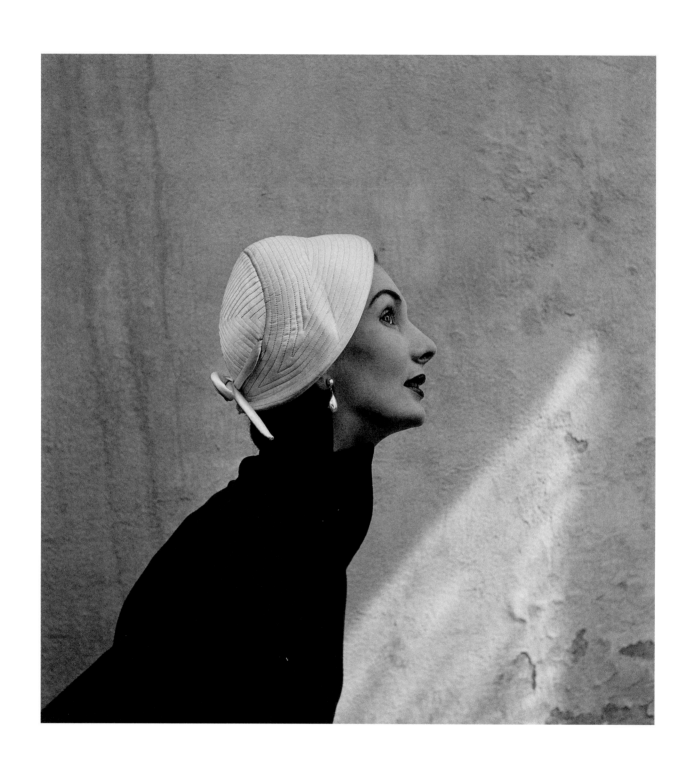

Barbara Goalen, 1948

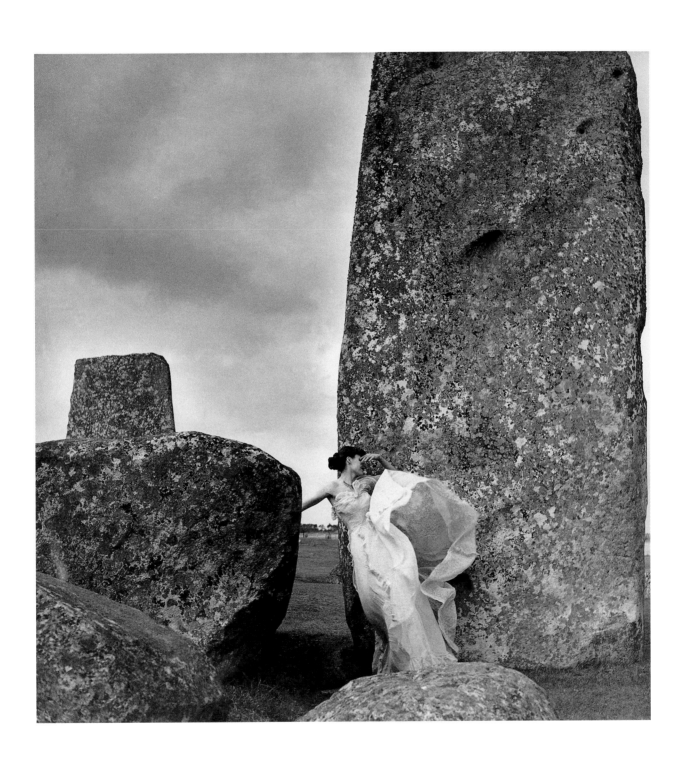

Cherry Litvinoff, 1948

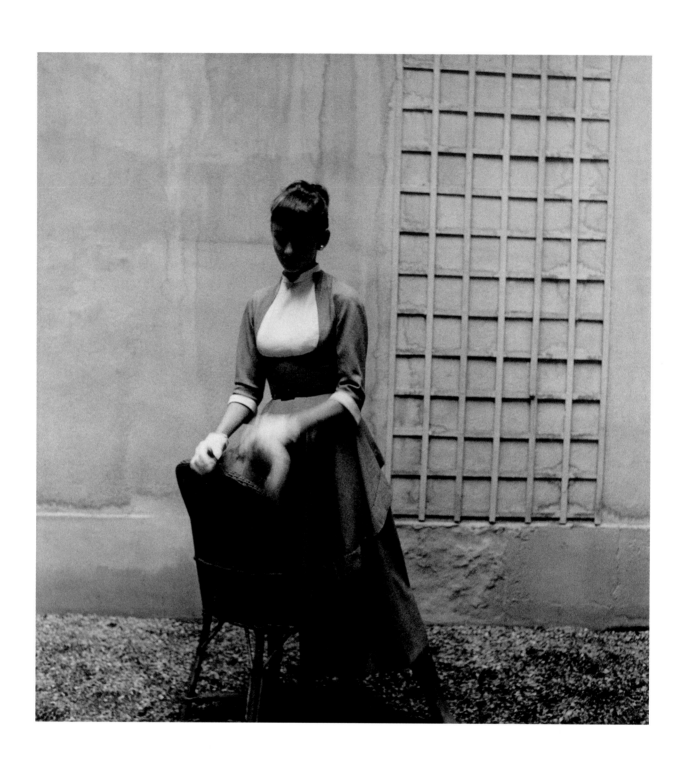

Sophie Malgat, 1948

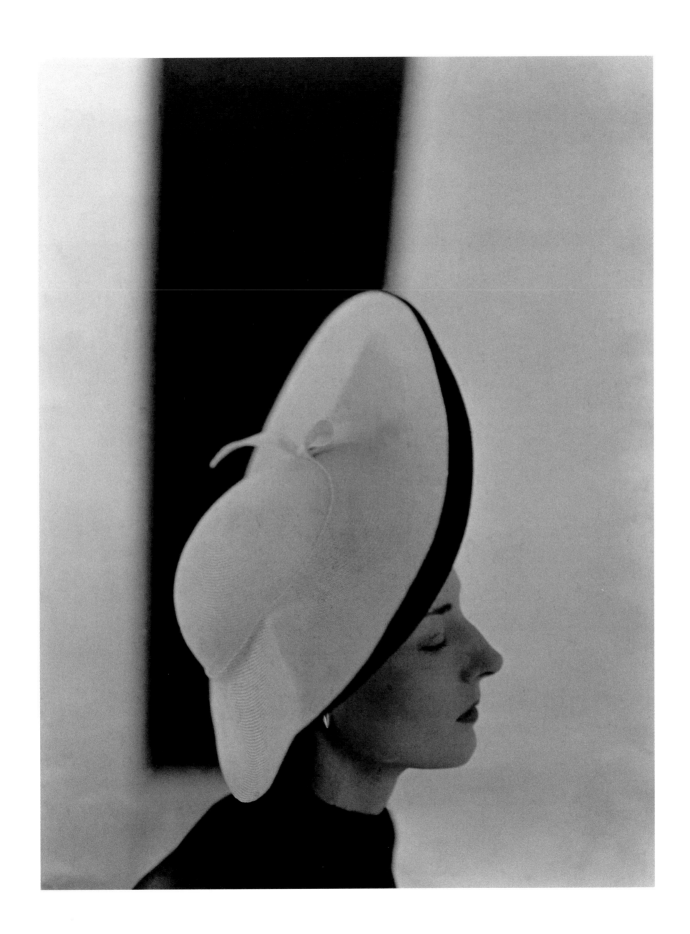

Patricia Cunningham, 1946

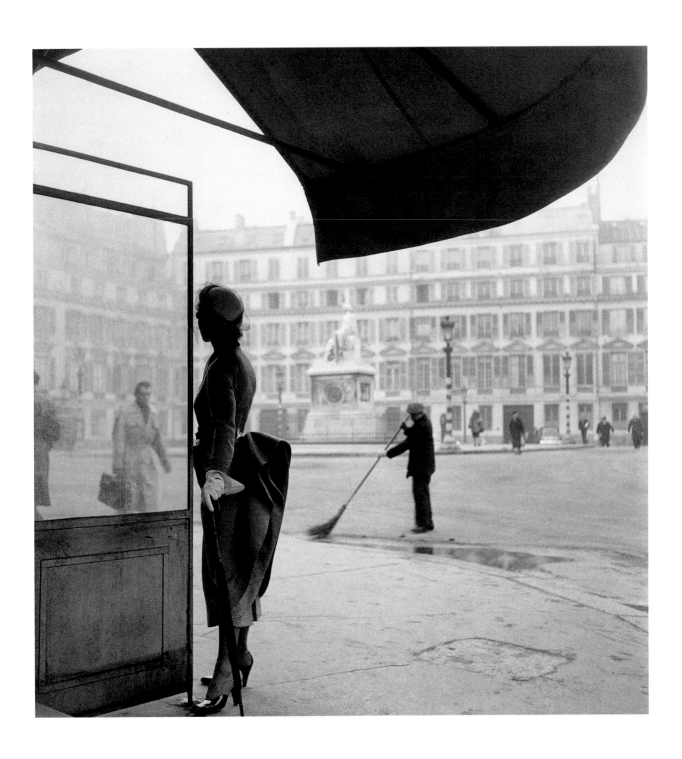

Unknown model, 1948

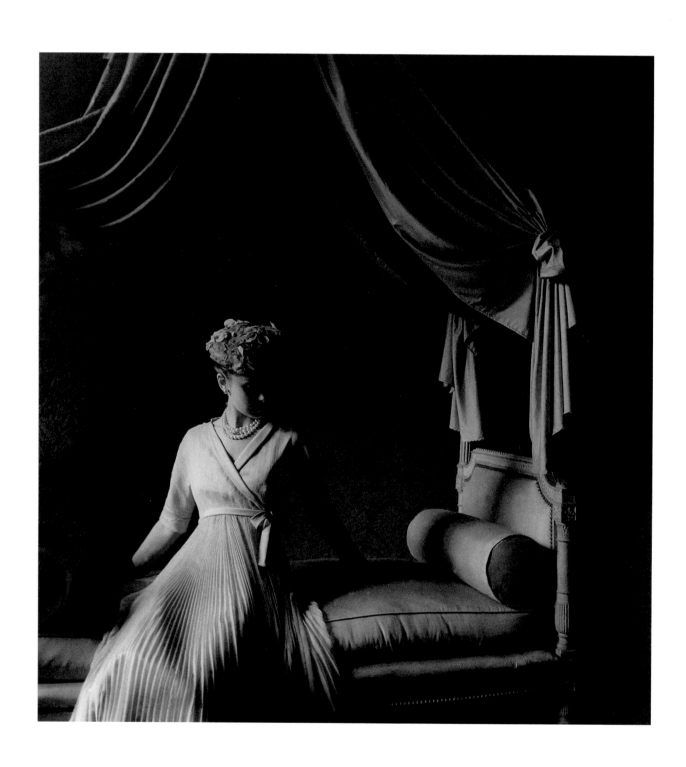

Unknown model, 1948

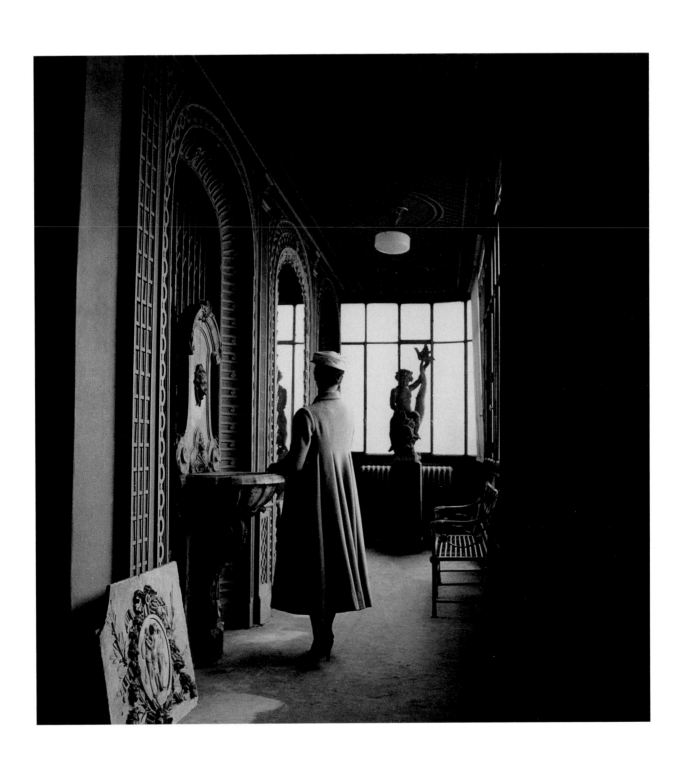

Unknown model, 1948

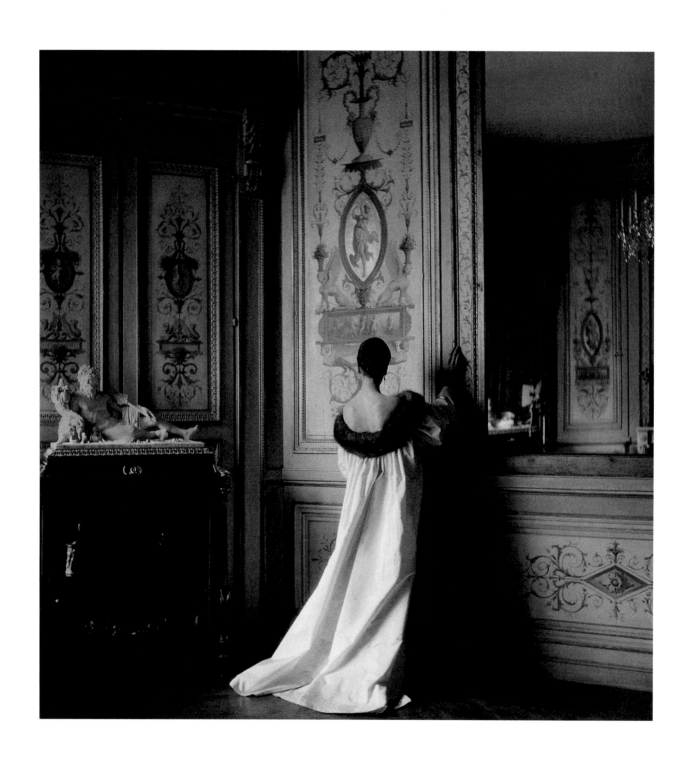

Unknown model, 1948

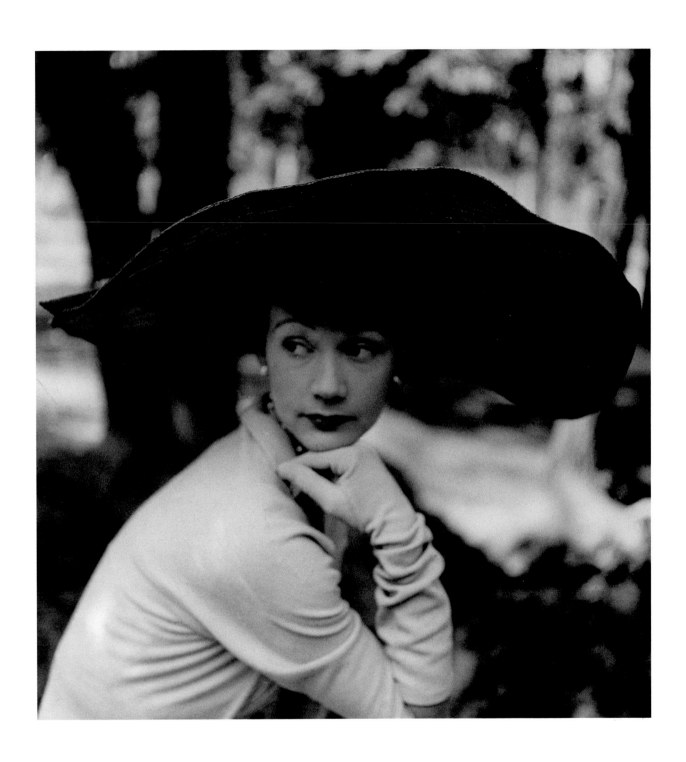

Sophie Malgat, 1948

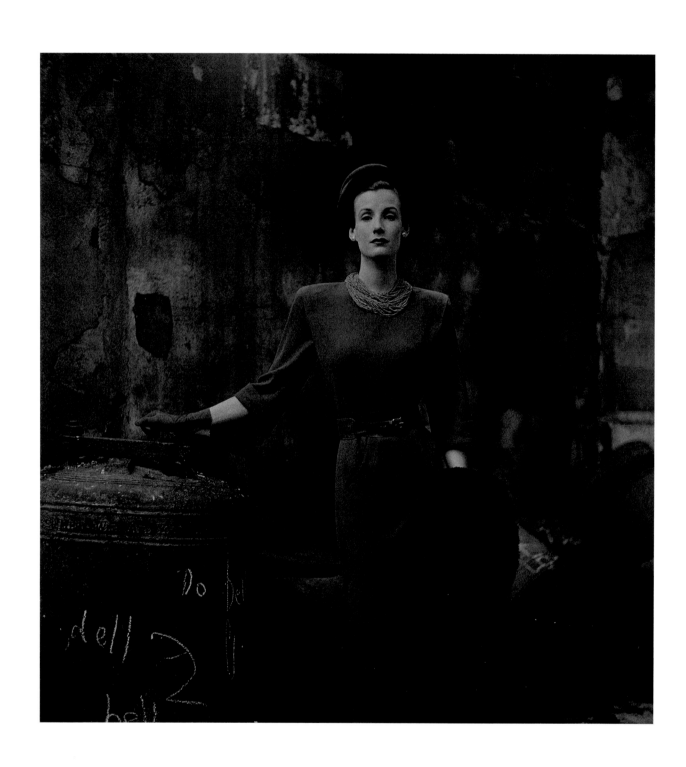

Wenda Rogerson, 1947

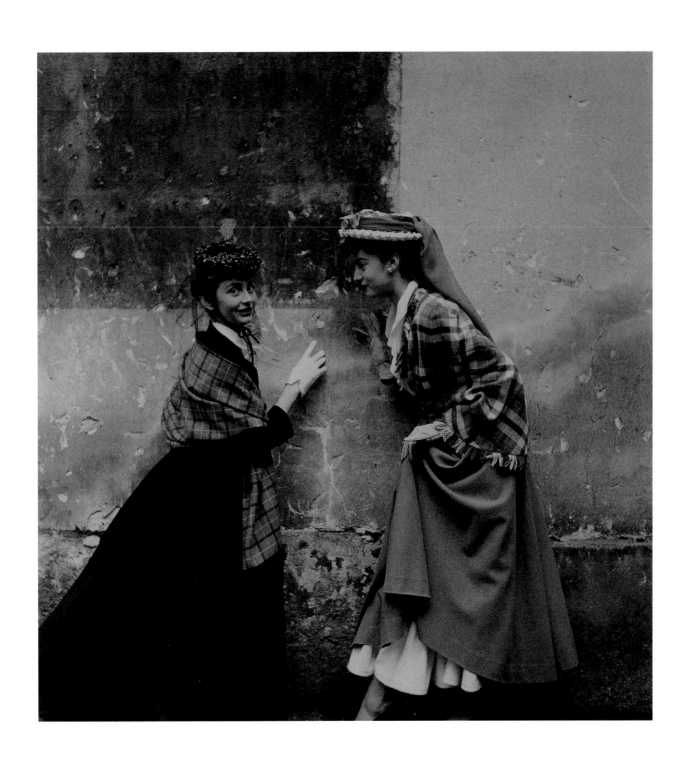

Unknown models, 1948

51

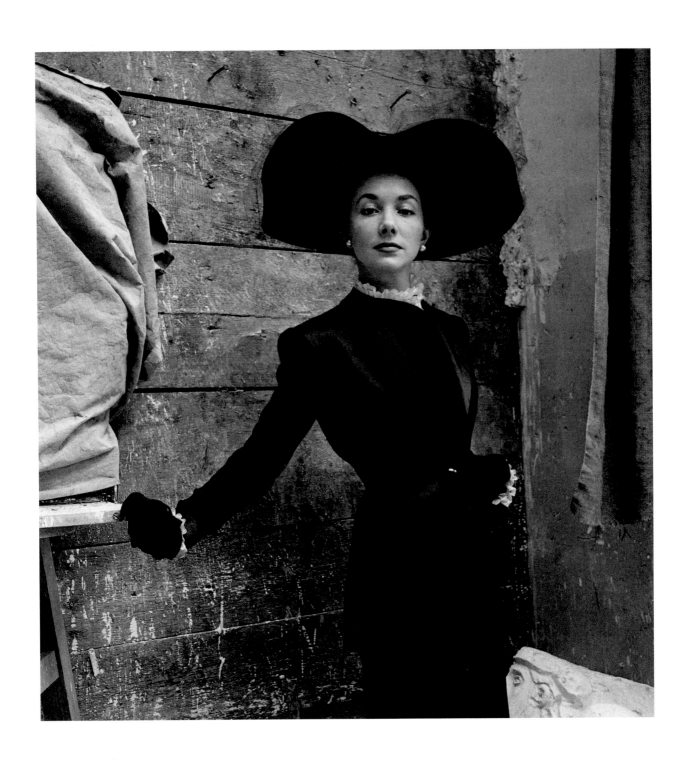

Unknown model, 1947

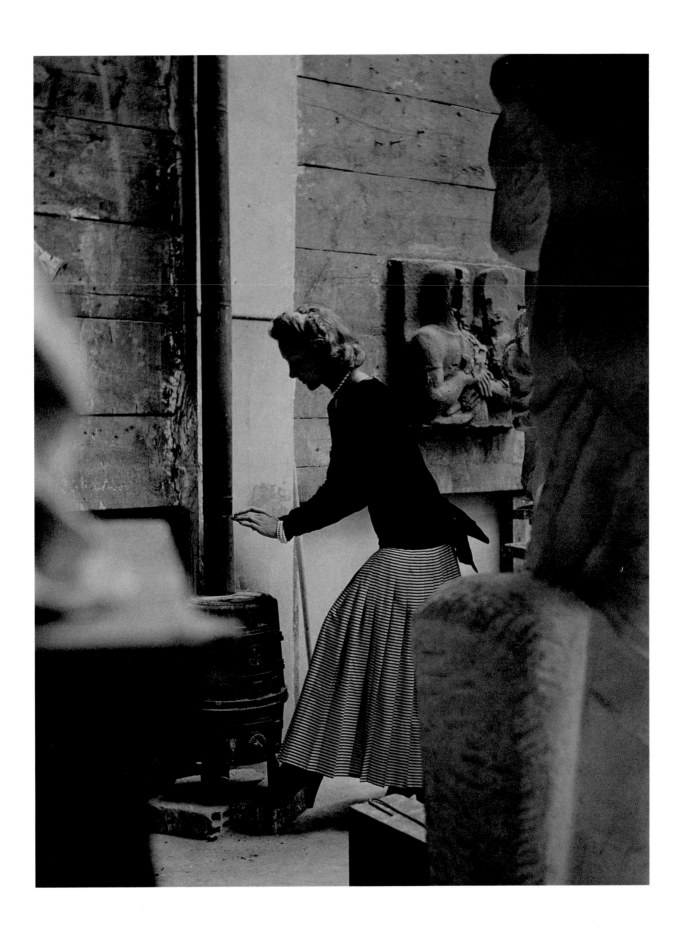

Unknown model, 1947

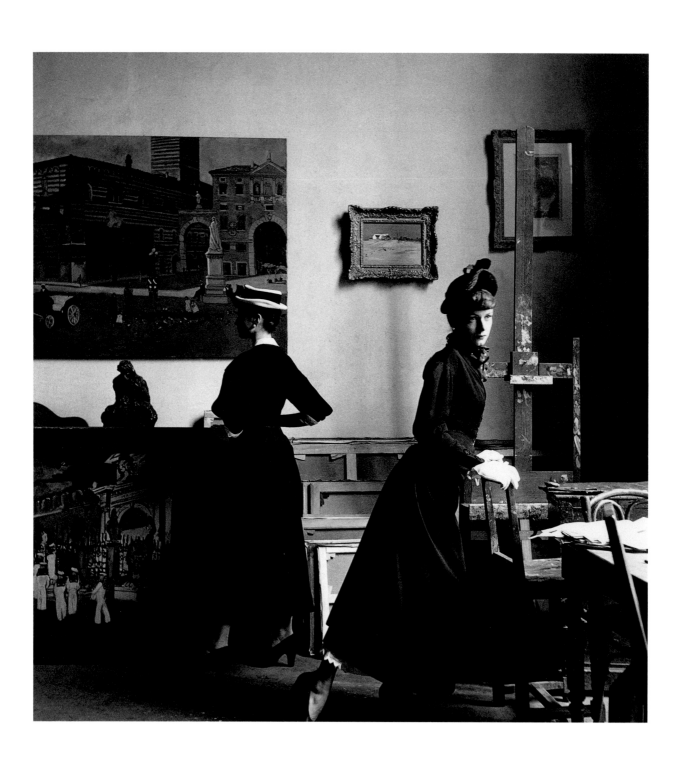

Sophie Malgat and unknown model, 1948

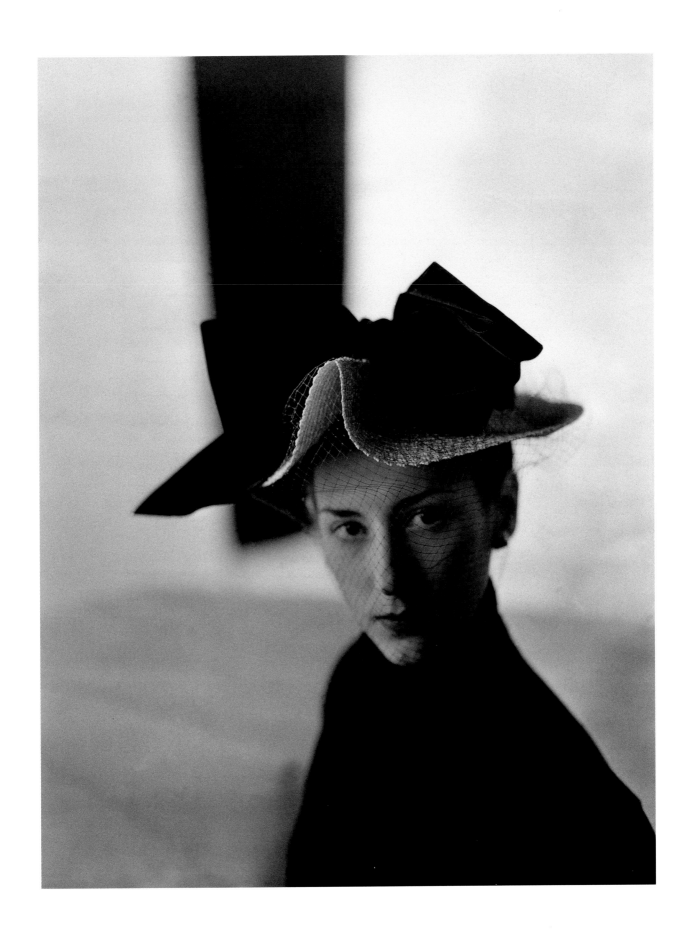

Patricia Cunningham, 1946

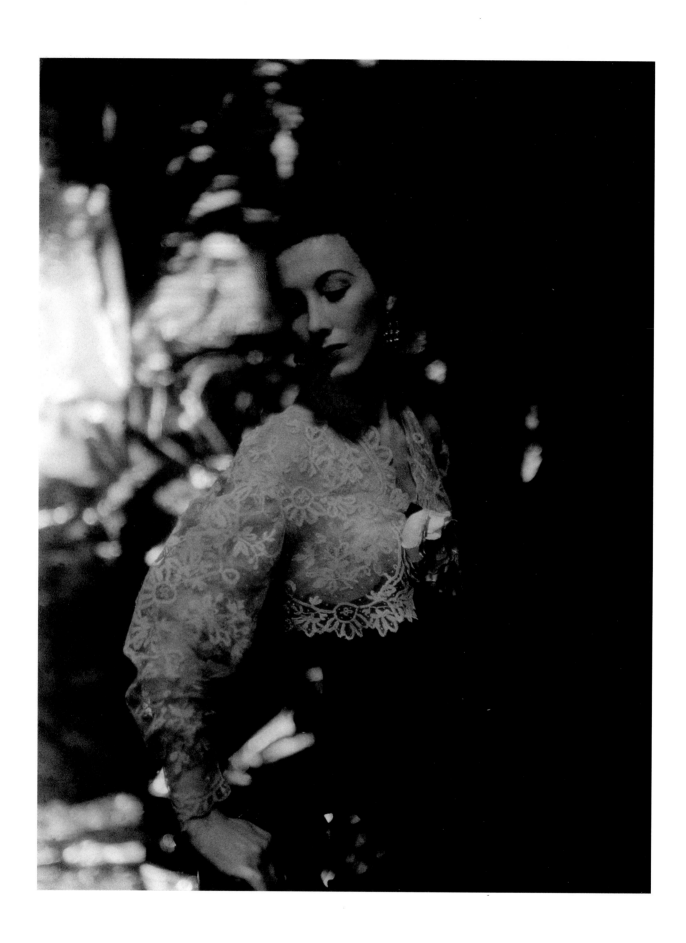

Isobel Babianska, 1947

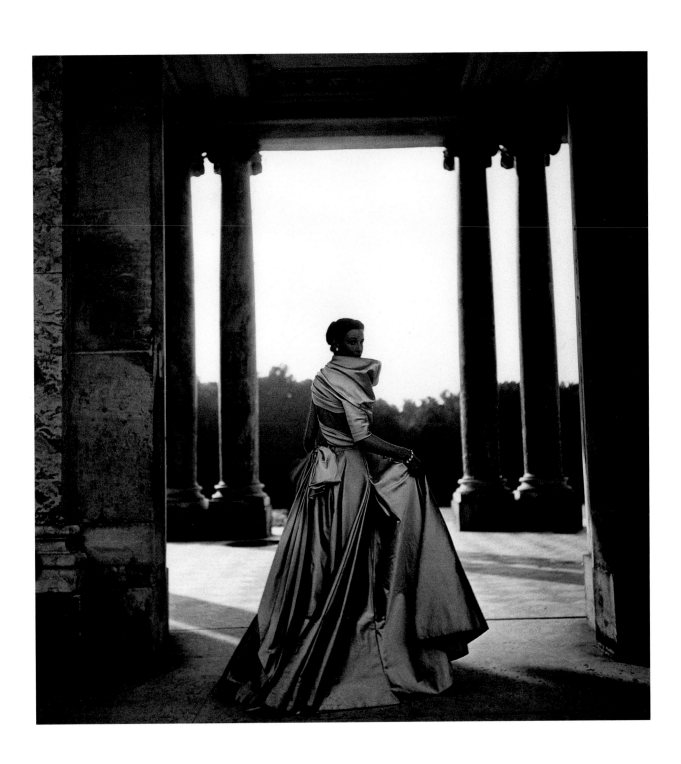

Wenda Rogerson, 1948

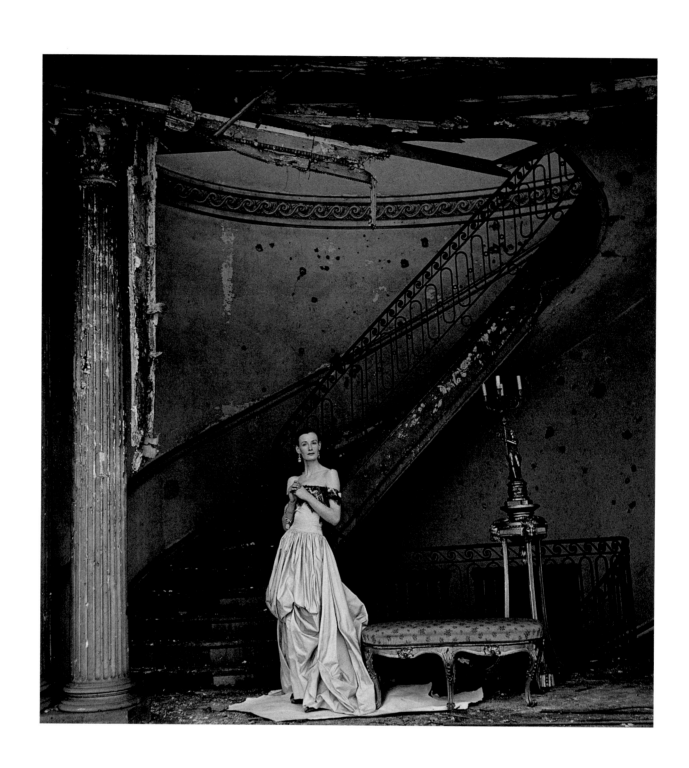

Wenda Rogerson, 1947

58

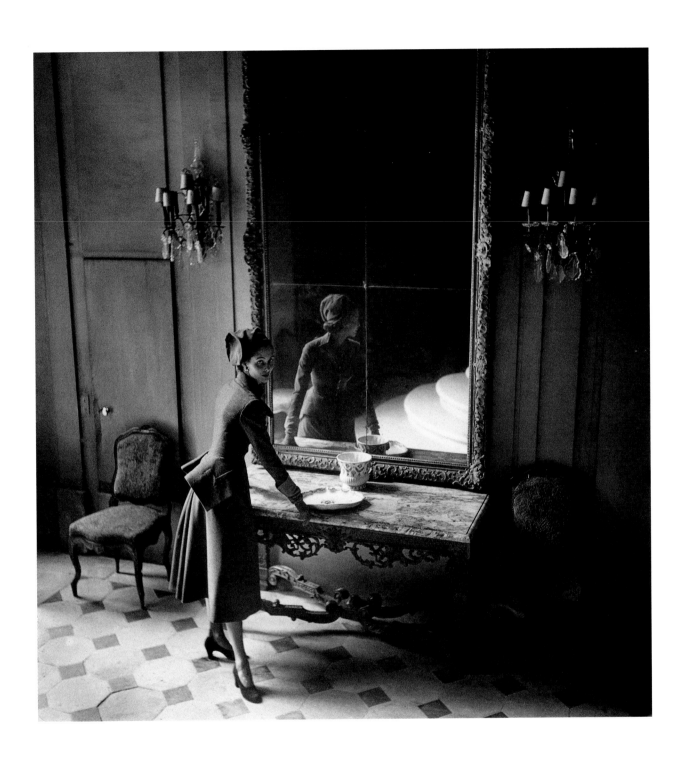

Janine Klein, 1948

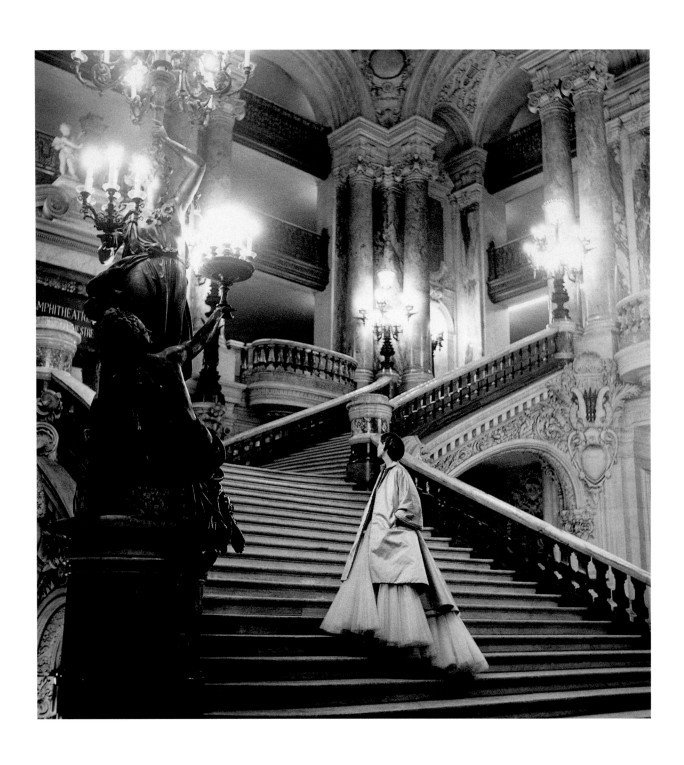

Wenda Rogerson, 1948

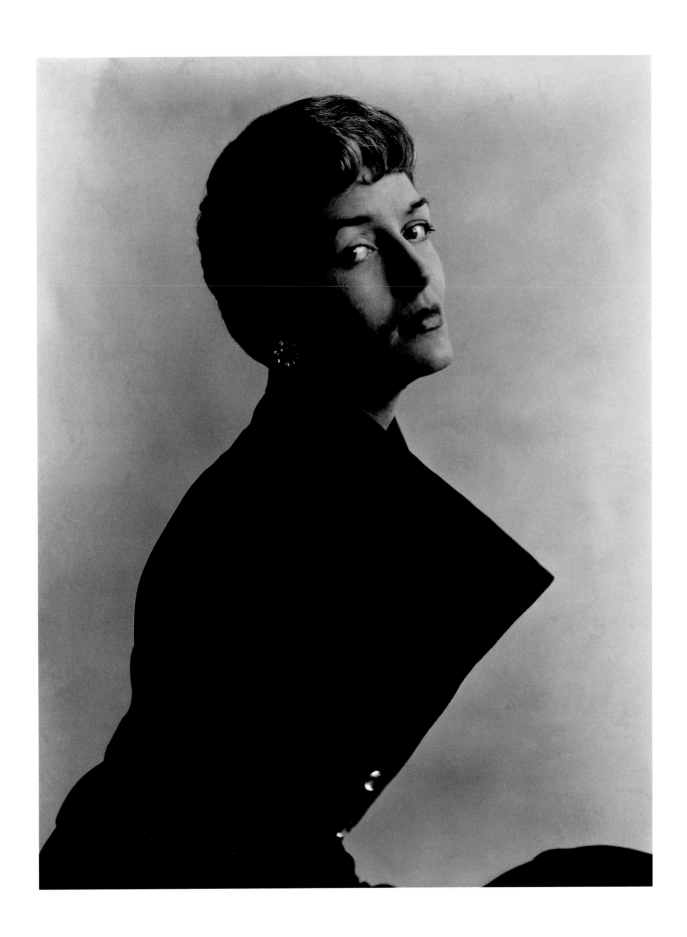

Comtesse Alain de la Falaise, 1948

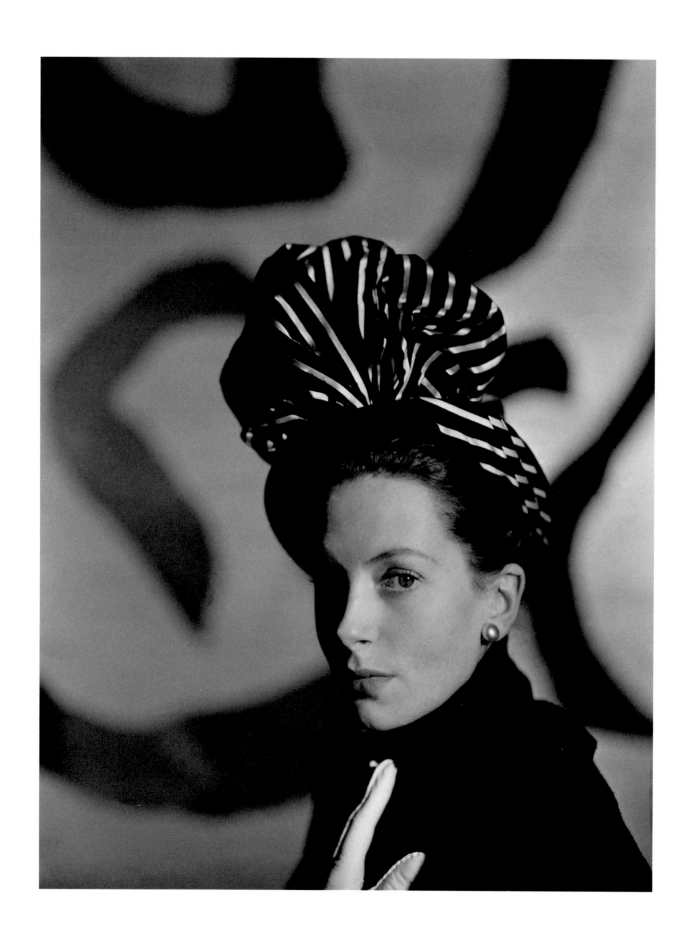

Deborah Kerr, 1946

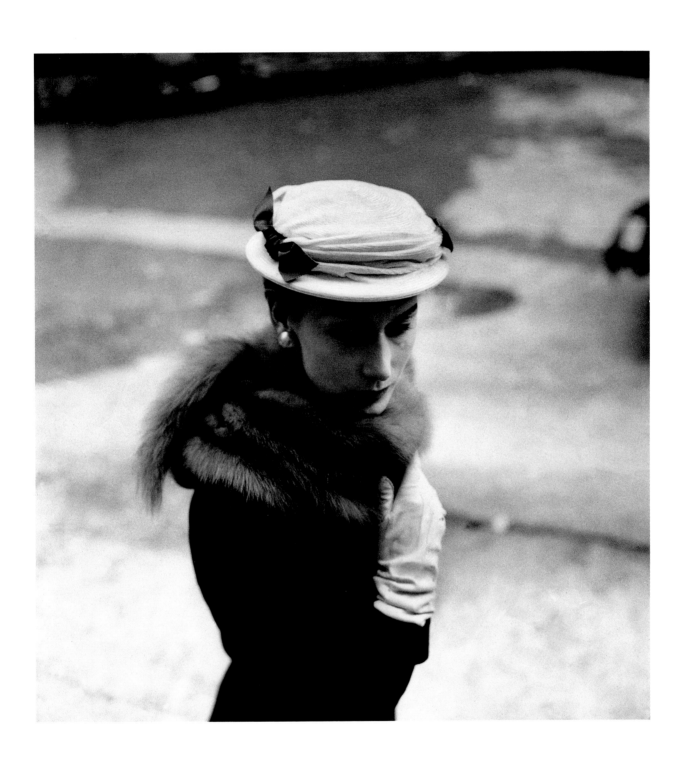

Helen Connor, 1954

Unknown model, 1948

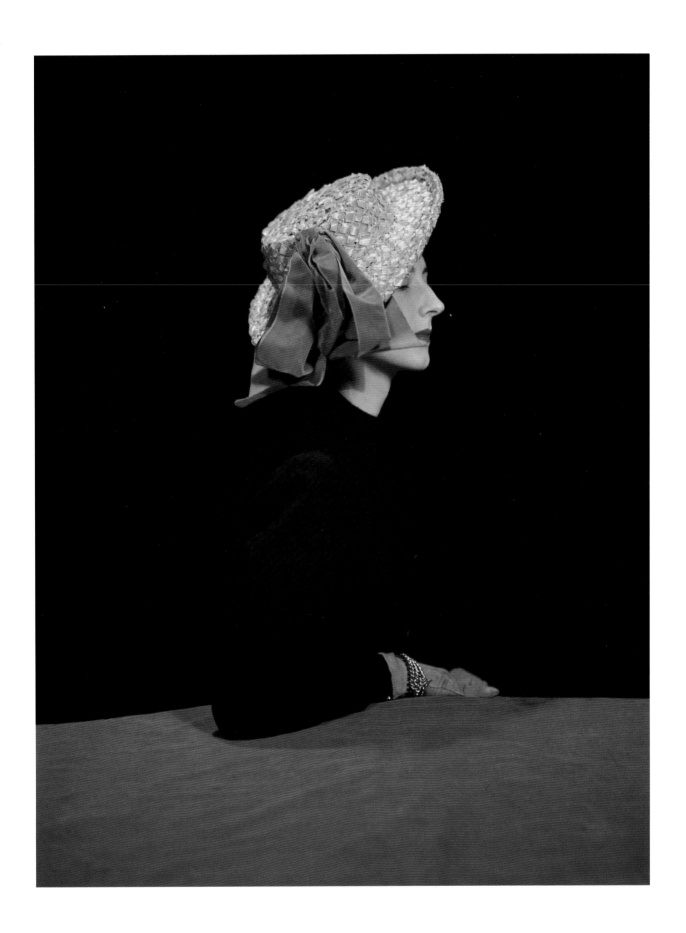

Patricia Cunningham, 1947

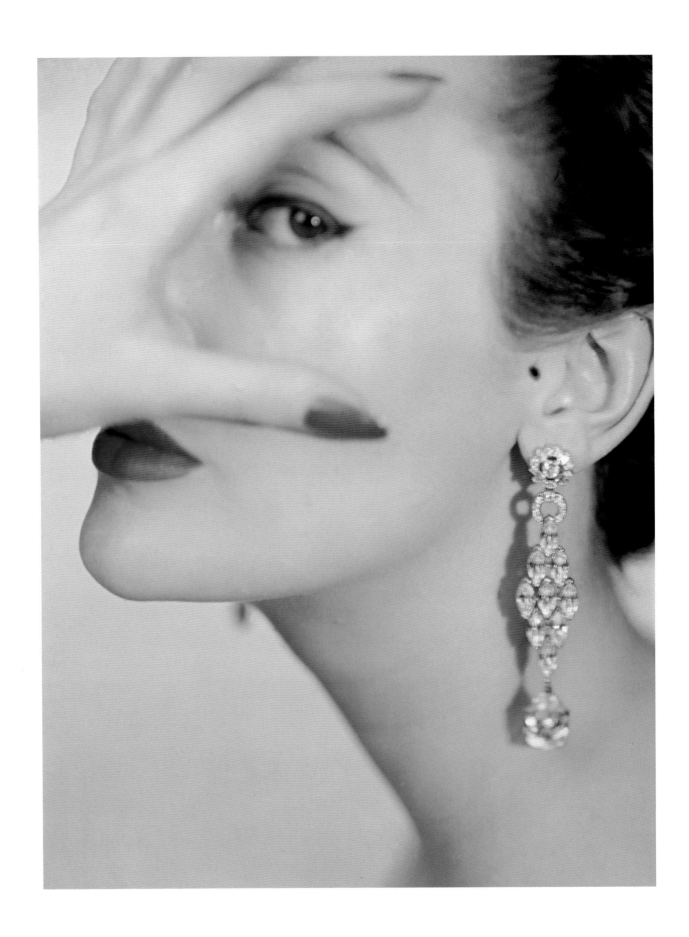

Mary Jane Russell, 1950

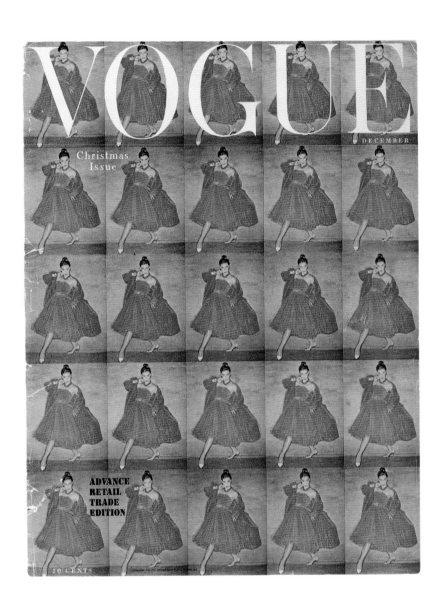

Unknown model, 1954

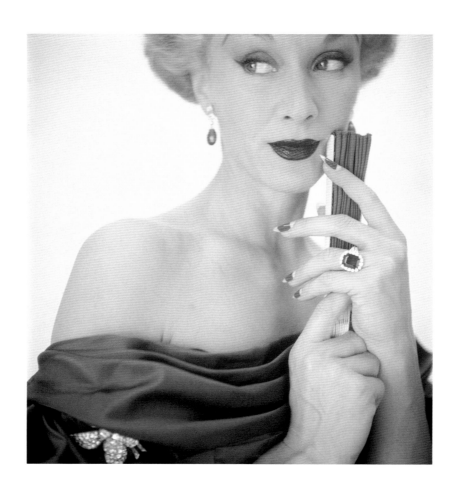

Lisa Fonssagrieves, 1951

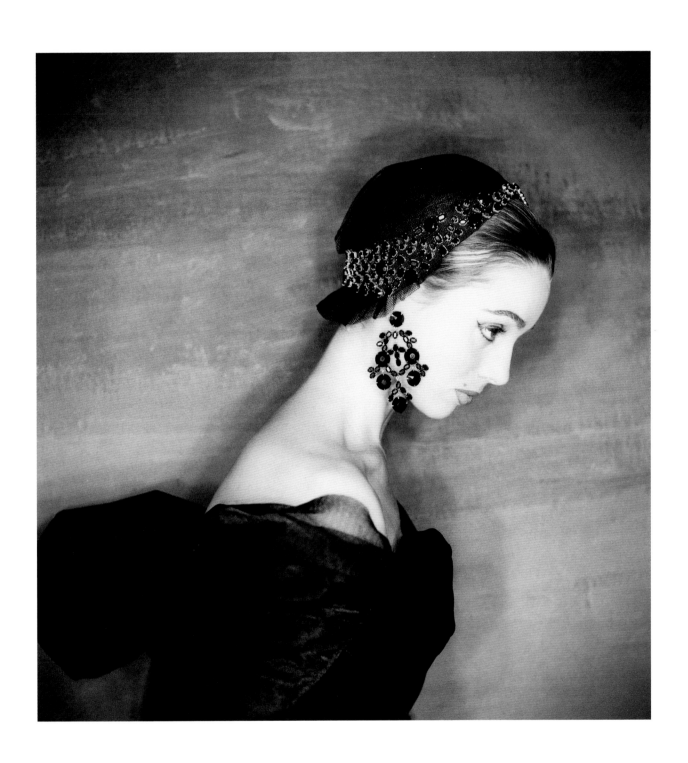

Elsa Martinelli, 1954

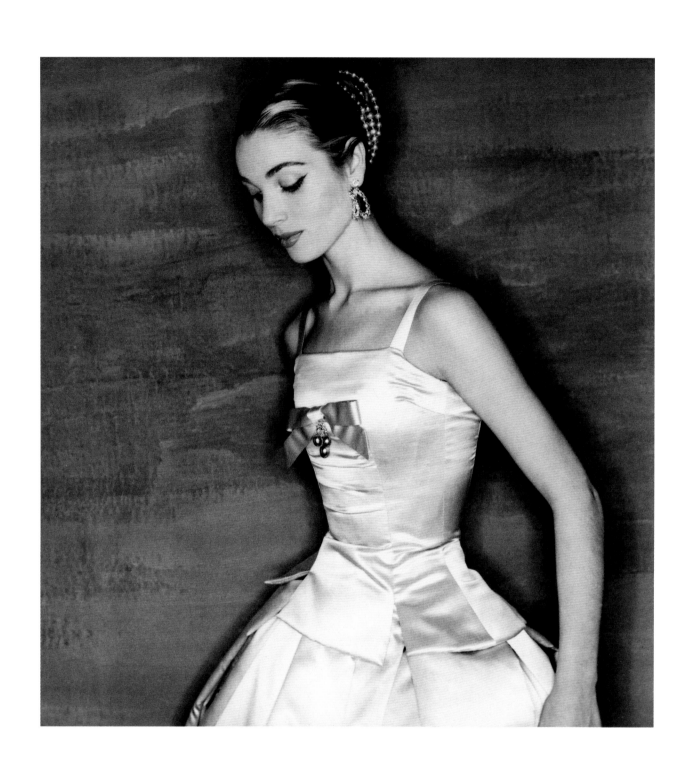

Nancy Berg, 1954

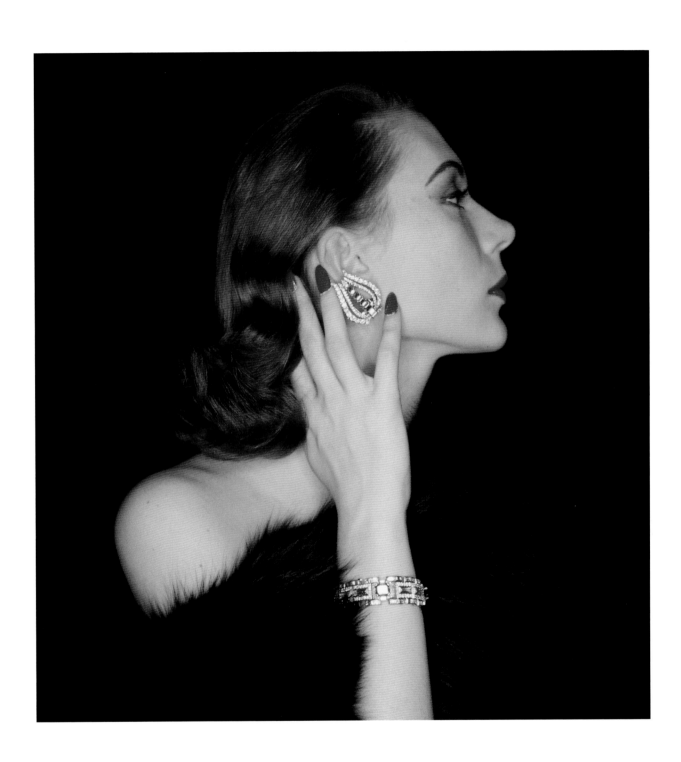

Svetlana Beriosova, 1954

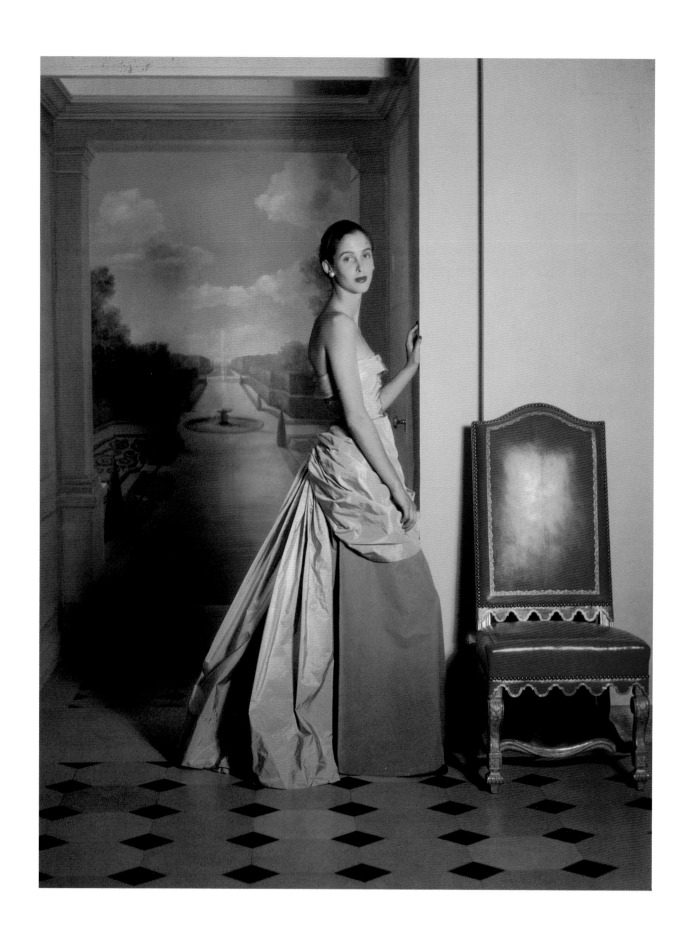

Janine Klein, 1948

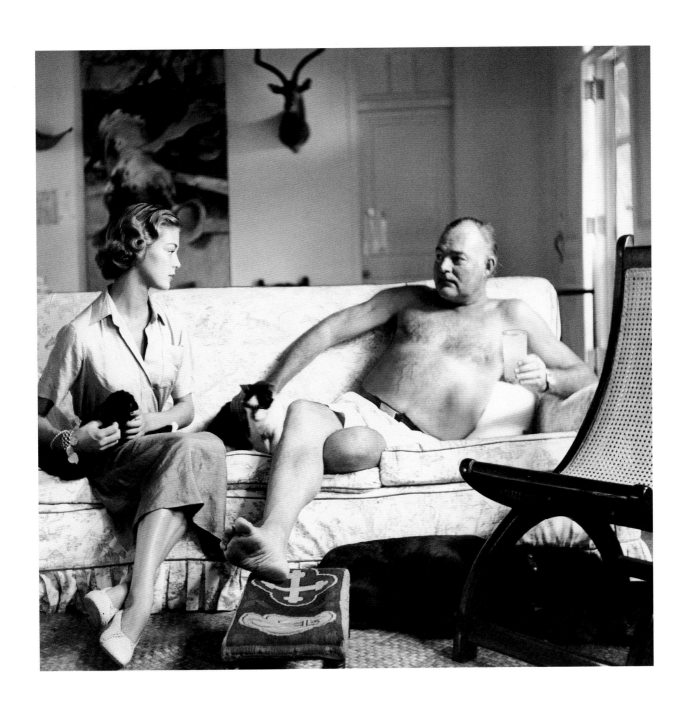

Jean Patchett and Ernest Hemingway, 1950

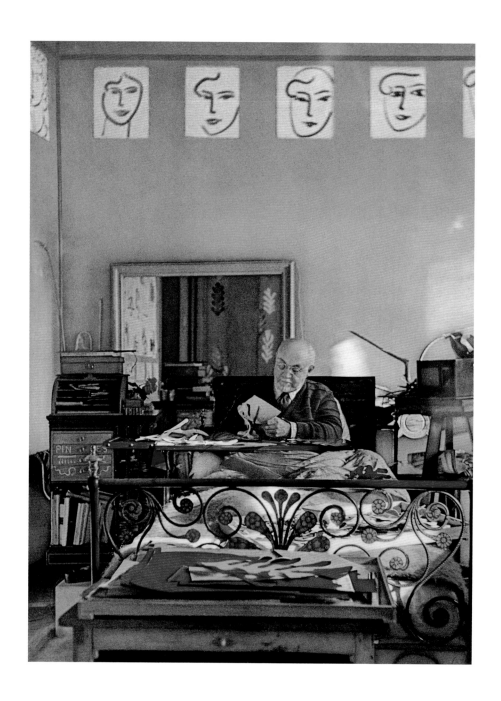

Henri Matisse, 1949

74

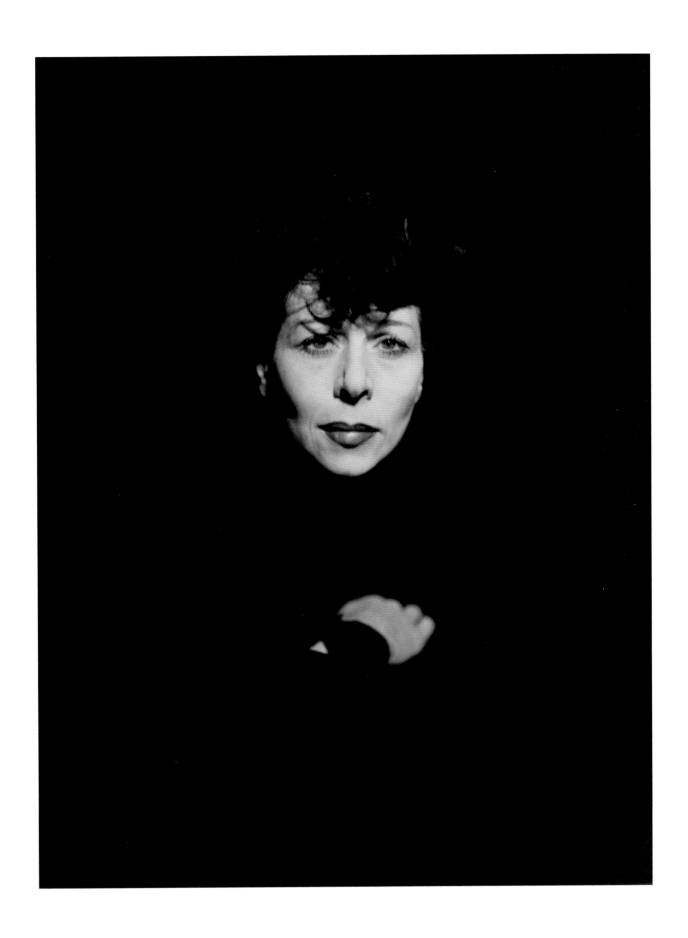

Jane Henderson, 1947

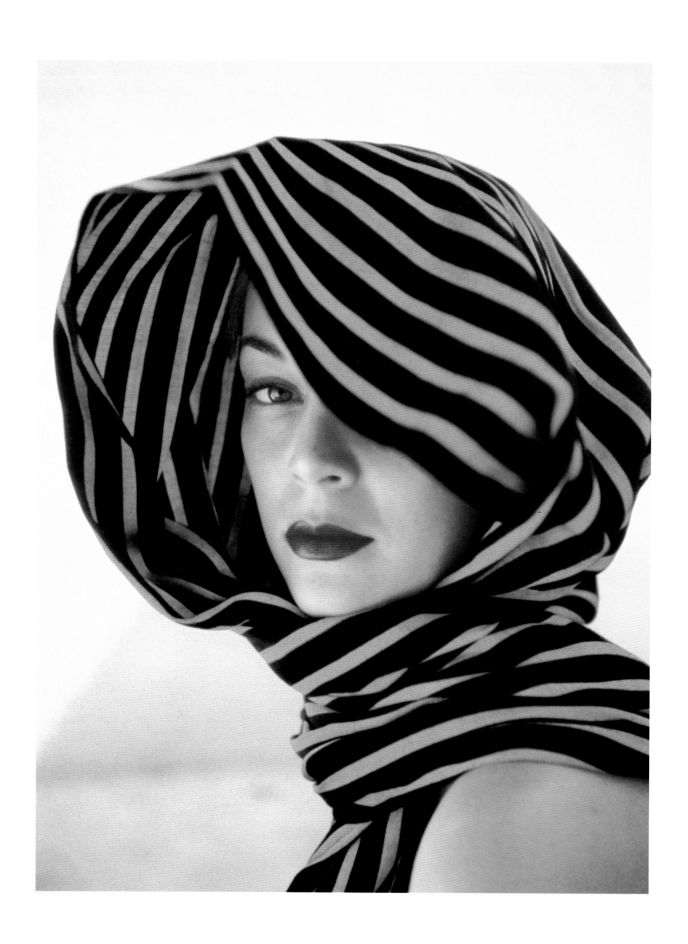

Jean Patchett, 1951

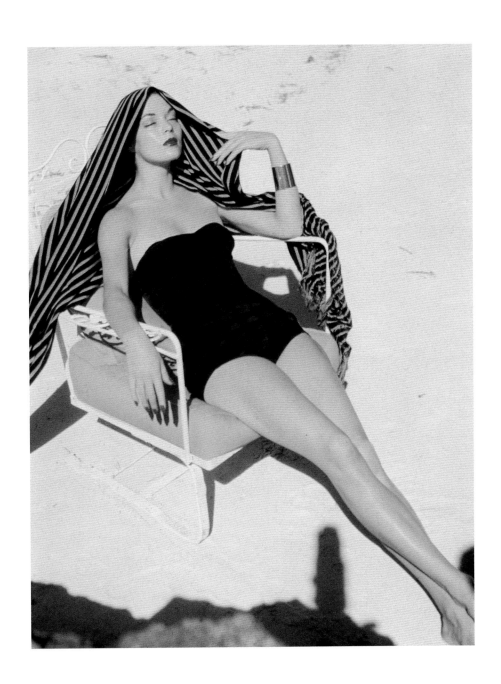

Jean Patchett, 1951

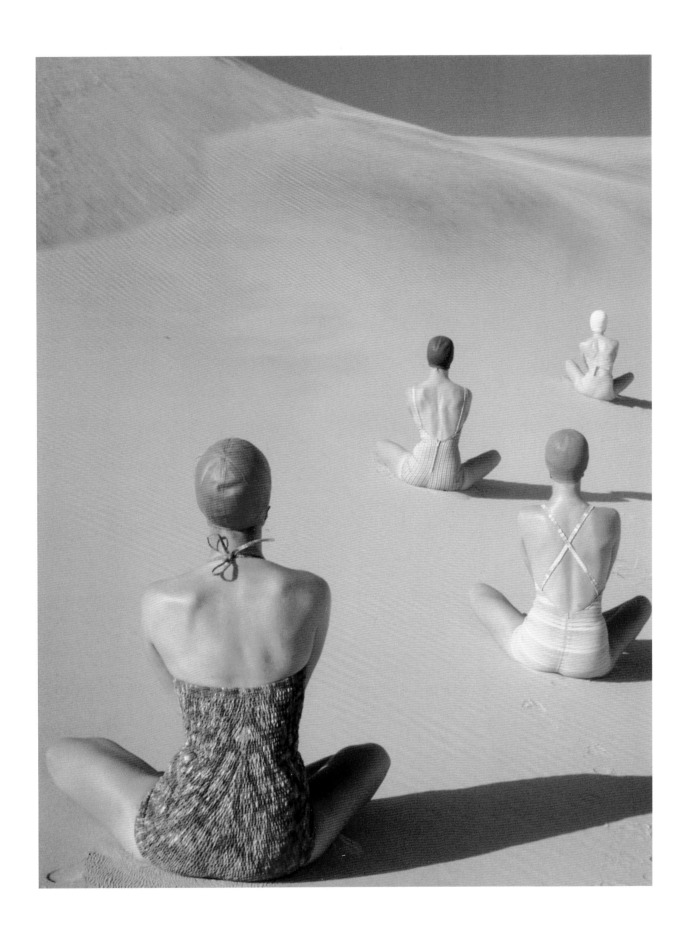

Unknown models, 1949

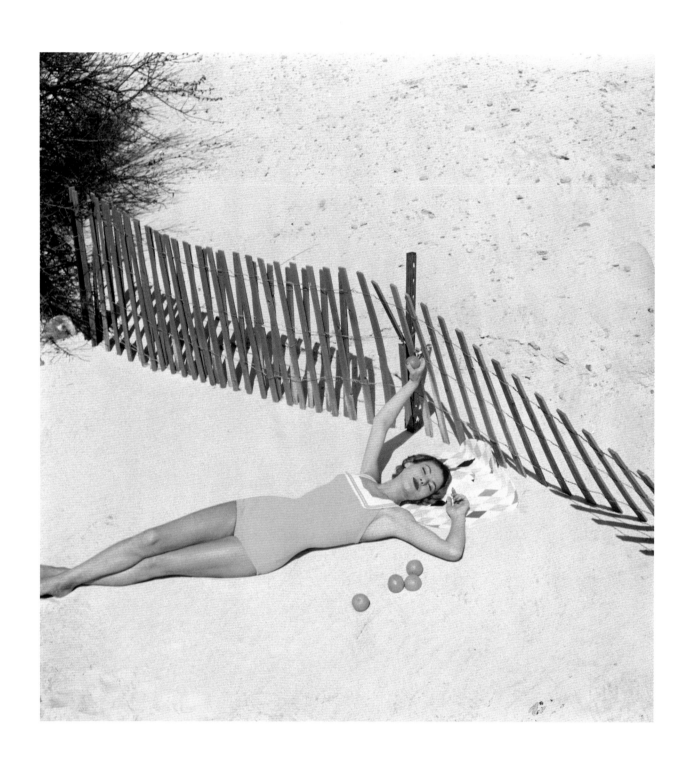

Unknown model, 1954

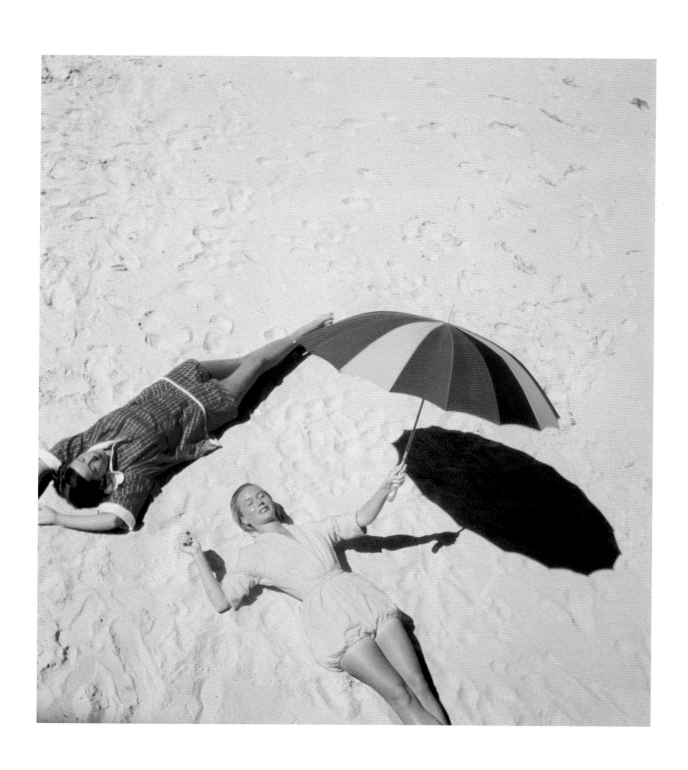

Unknown models, 1949

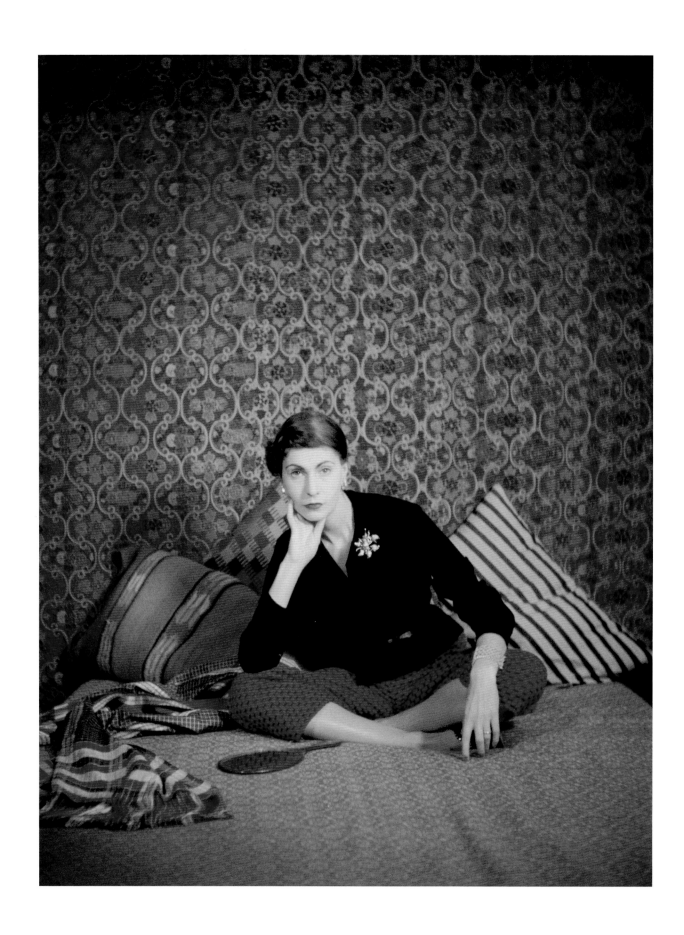

Countess Uberto Corti, 1950

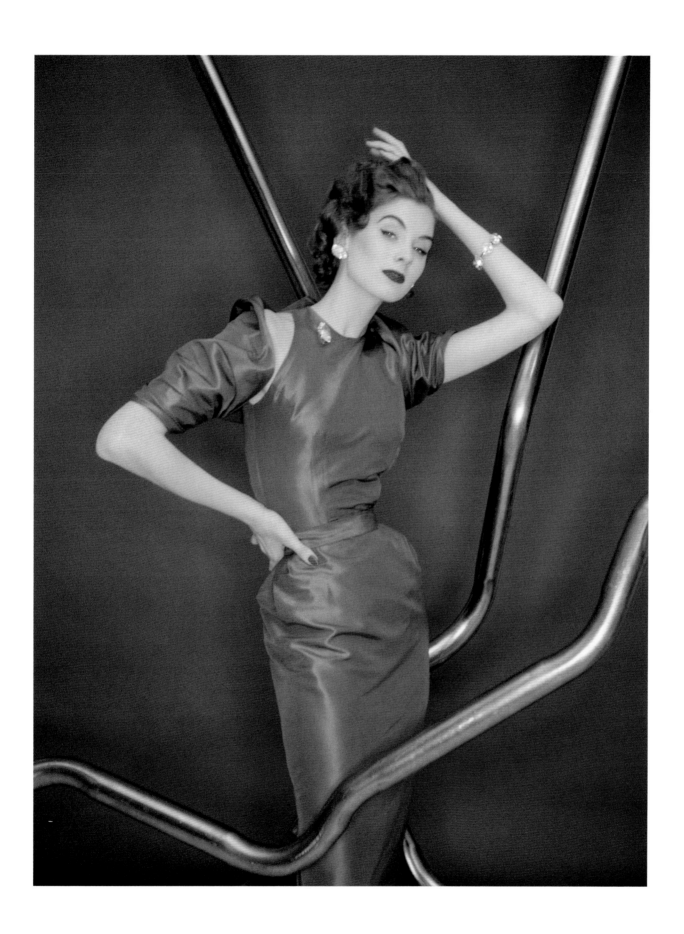

Suzy Parker, 1953

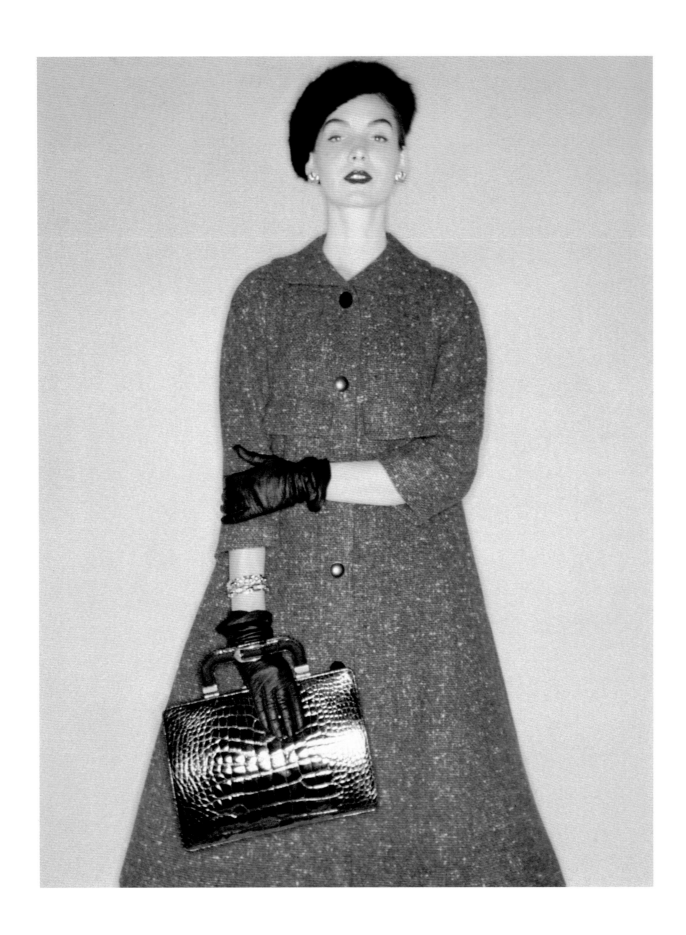

Cherry Nelms, 1955

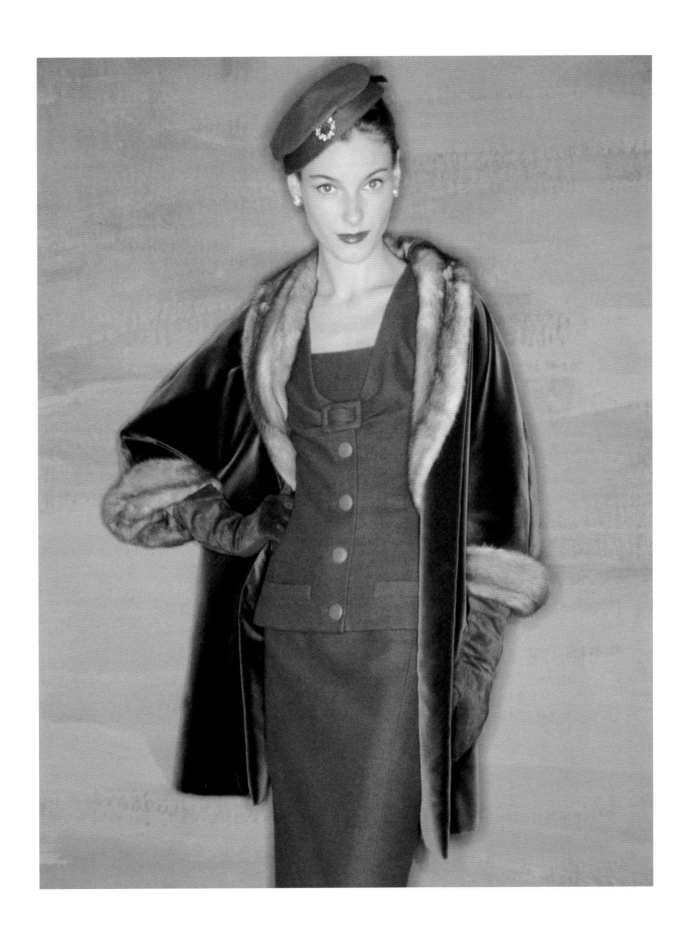

Marilyn Ambrose, 1954

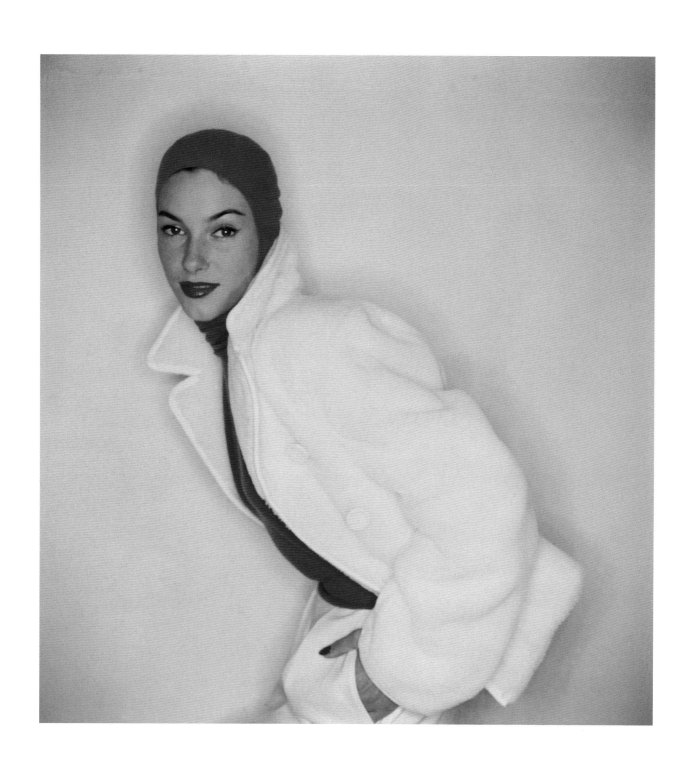

Unknown model, 1954

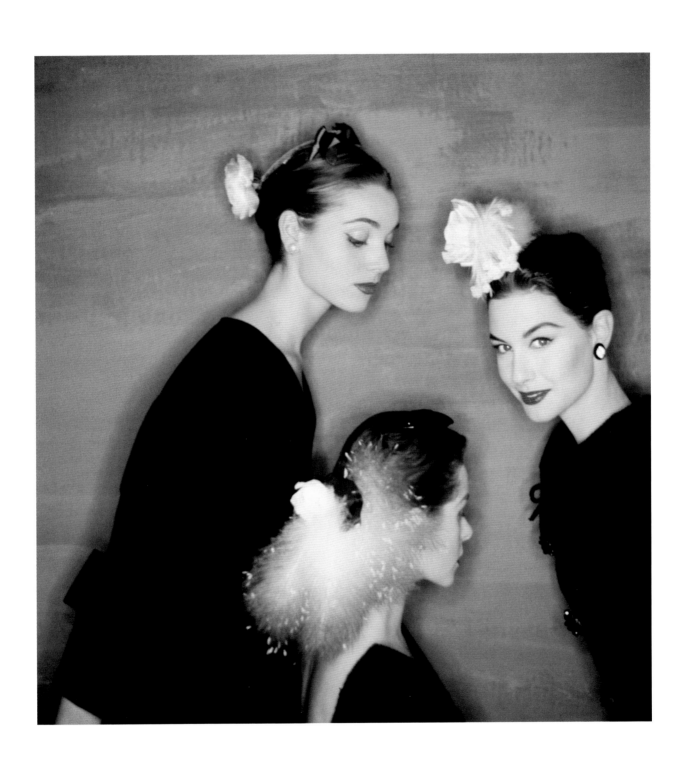

Nancy Berg, Candy Tannev and Elsa Martinelli, 1954

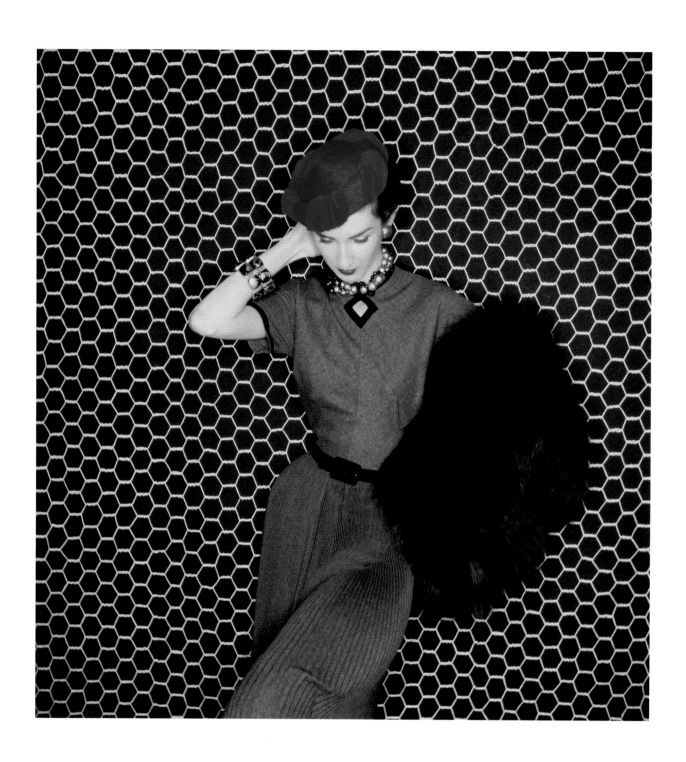

Unknown model, 1952

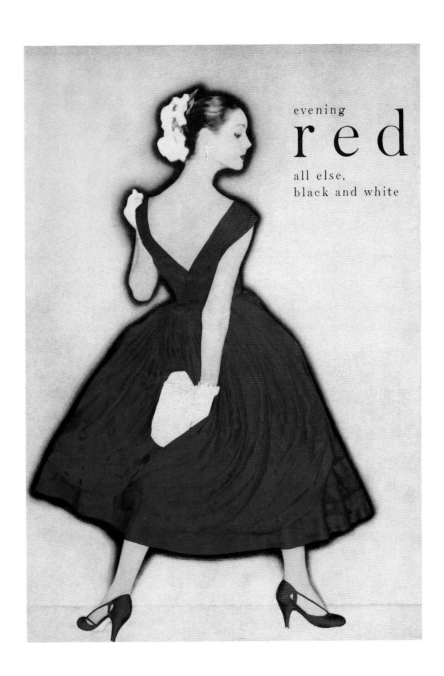

Unknown model, 1955

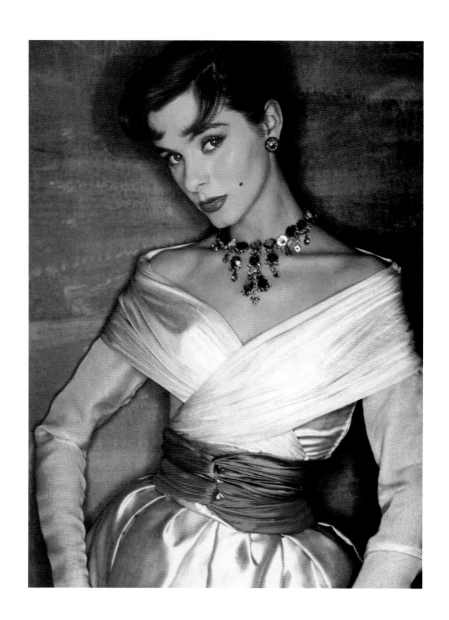

Unknown model, 1954

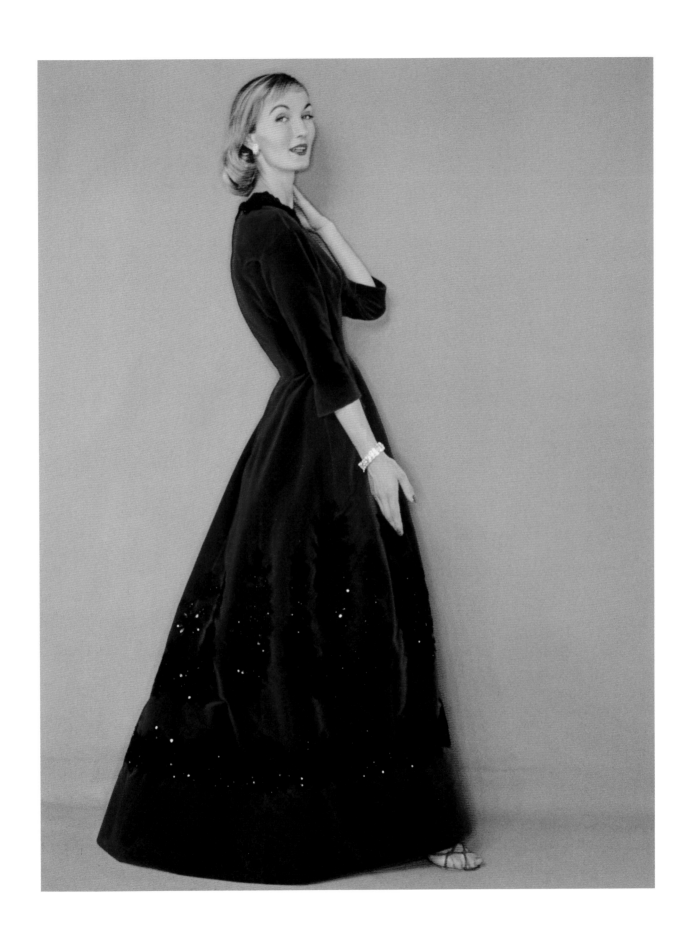

Evelyn Tripp, 1955

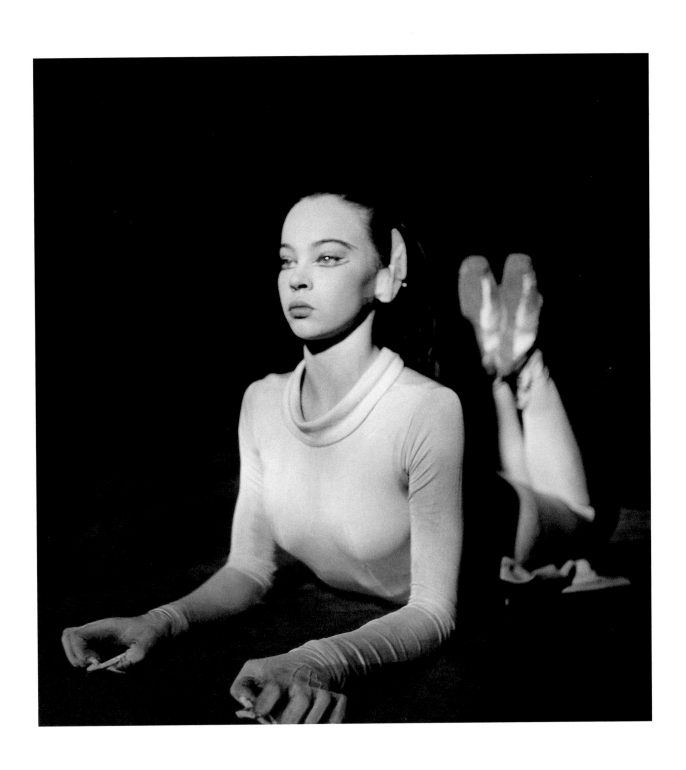

Leslie Caron, 1948

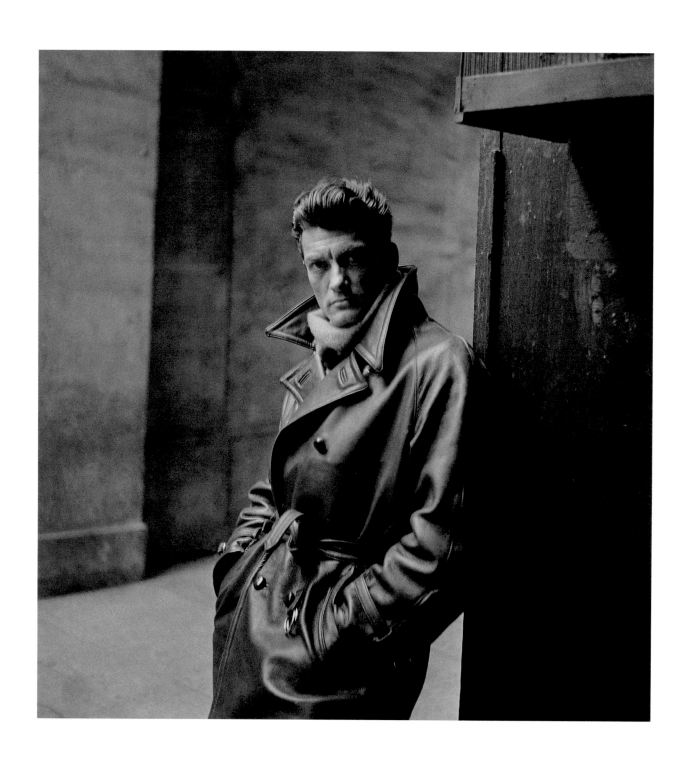

Jean Marais, 1946

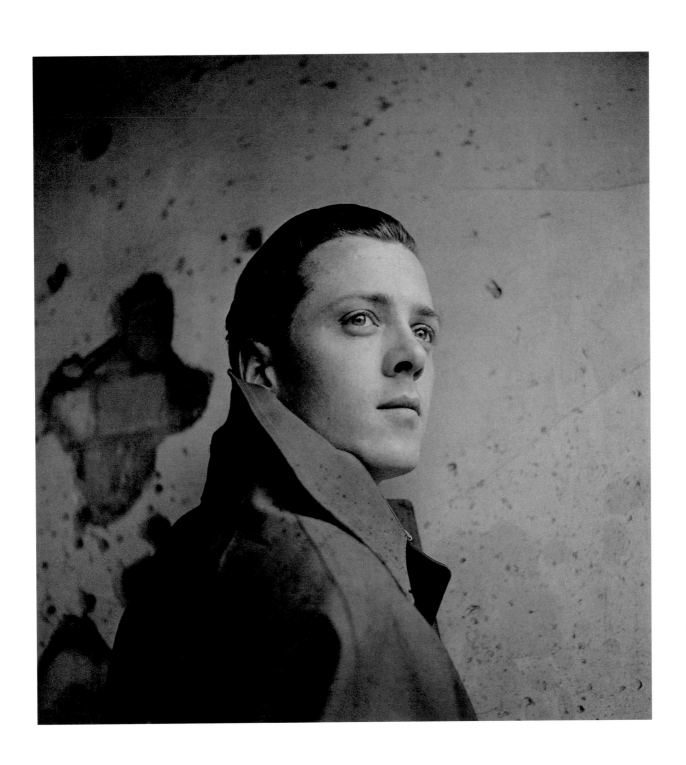

Richard Attenborough, 1947

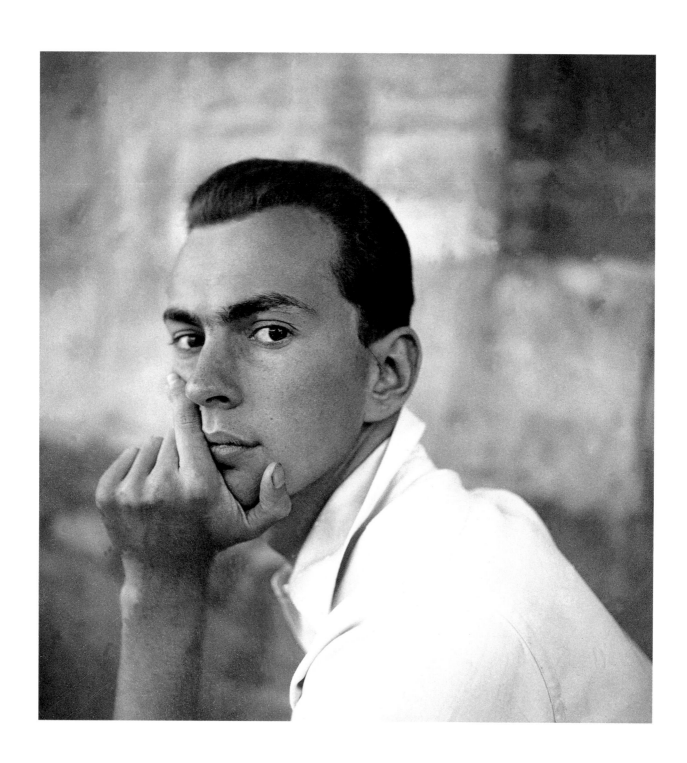

Gore Vidal, 1949

Gérard Philipe, 1948

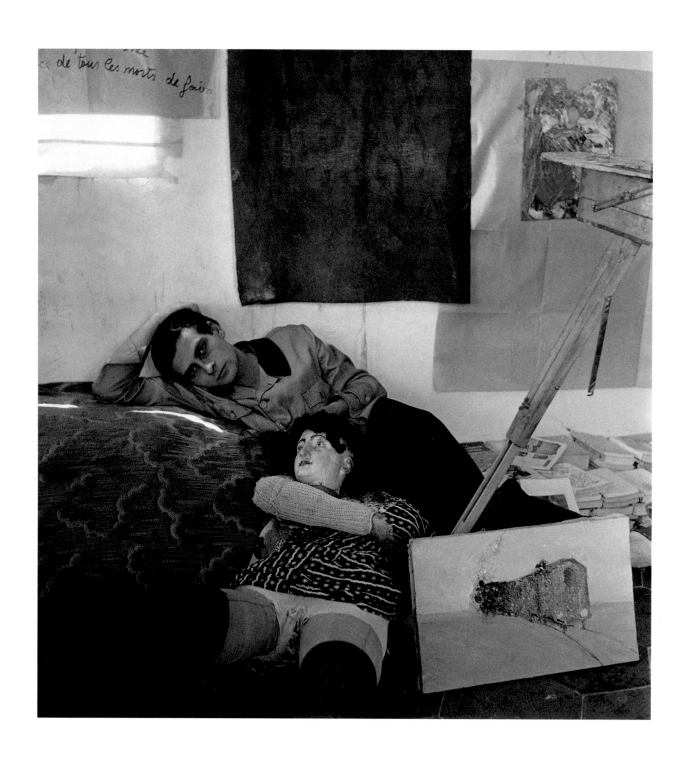

Renzo Vespignani, 1946

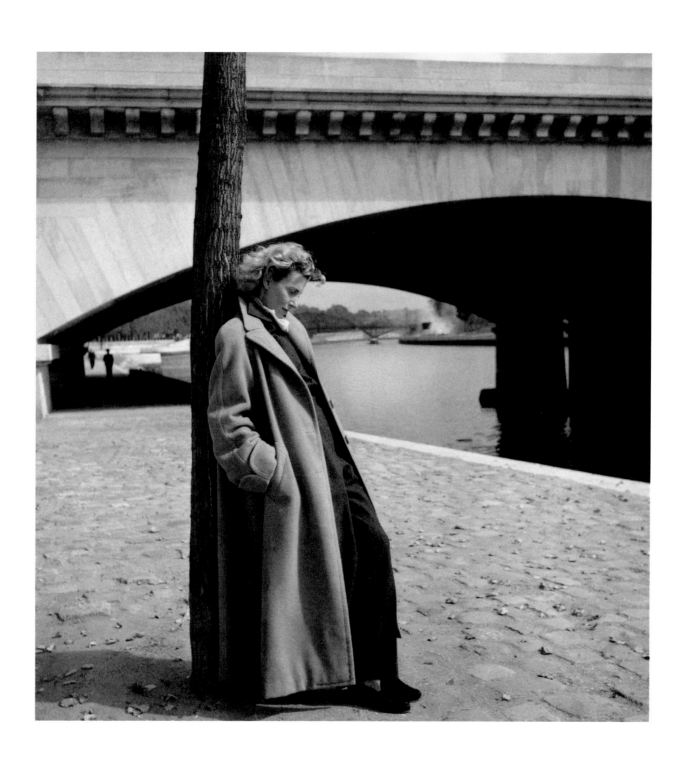

Princess Cyril Troubetskoy, 1946

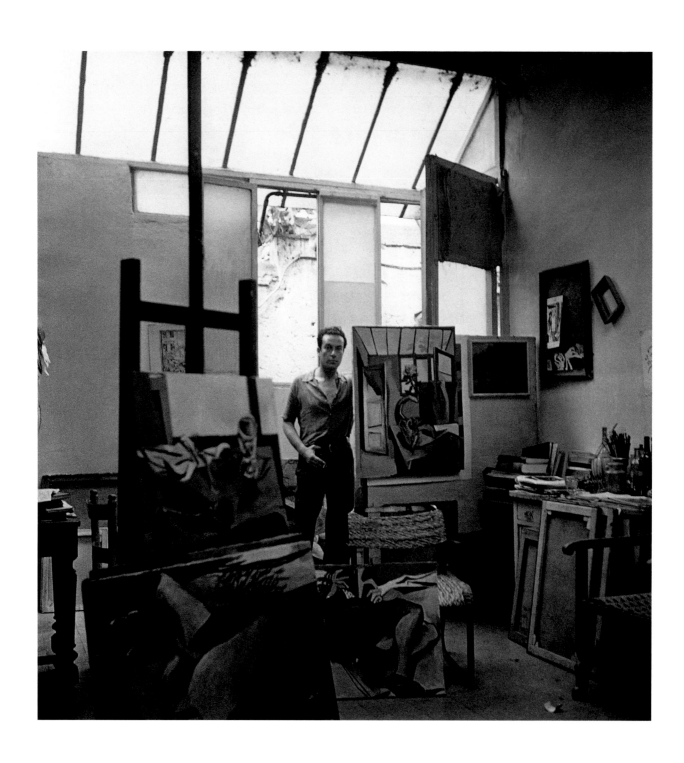

Renato Guttuso, 1946

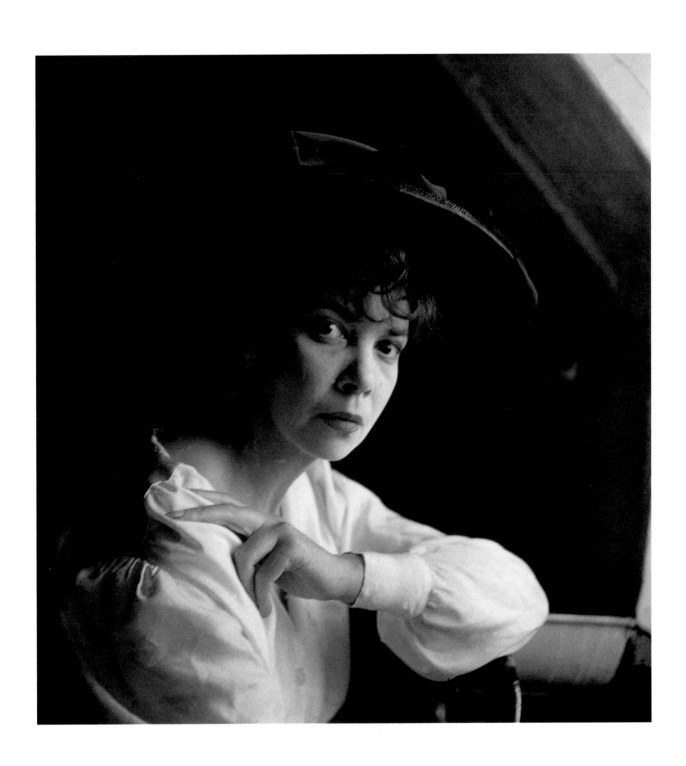

Léonor Fini, 1946

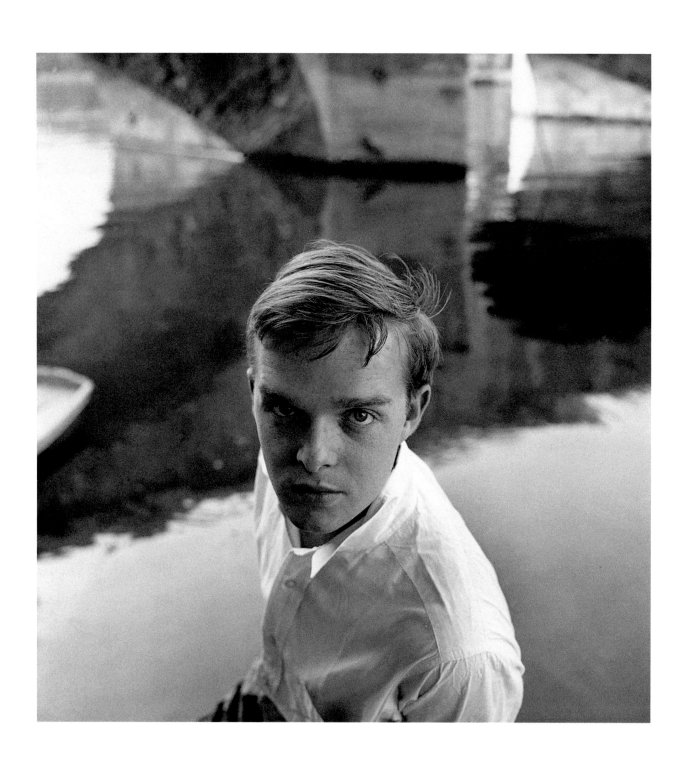

Truman Capote, 1948

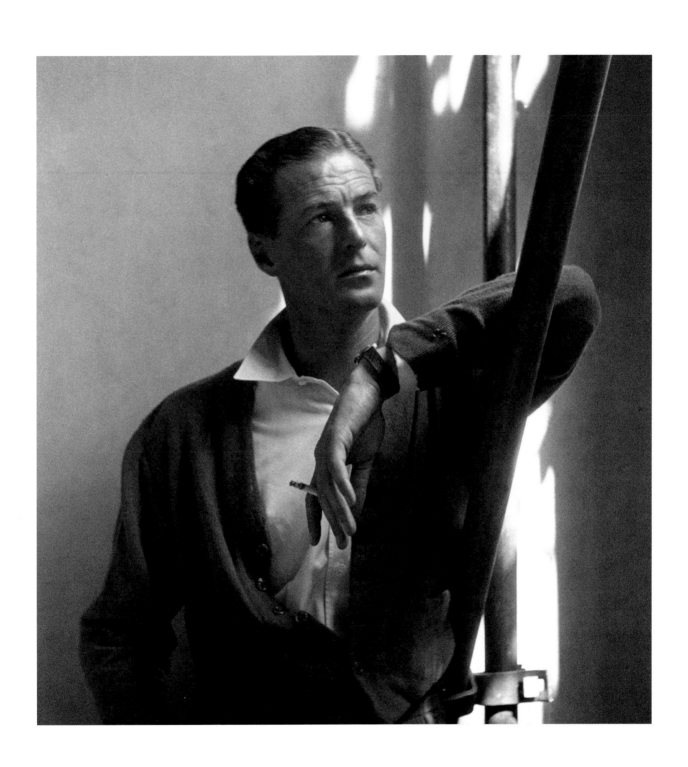

Terence Rattigan, 1947

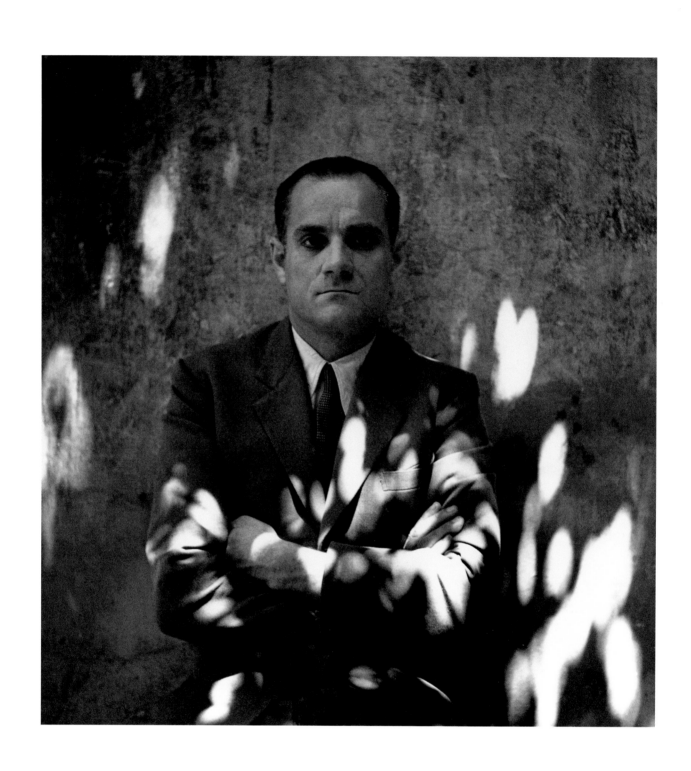

Alberto Moravia, 1946

Vivien Leigh, 1947

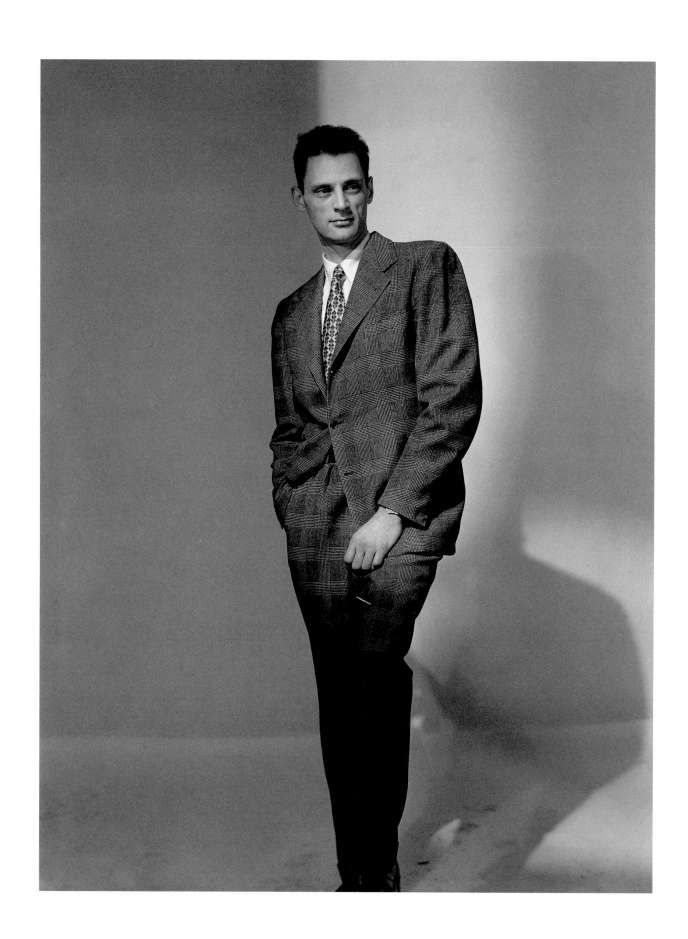

Arthur Miller, 1947

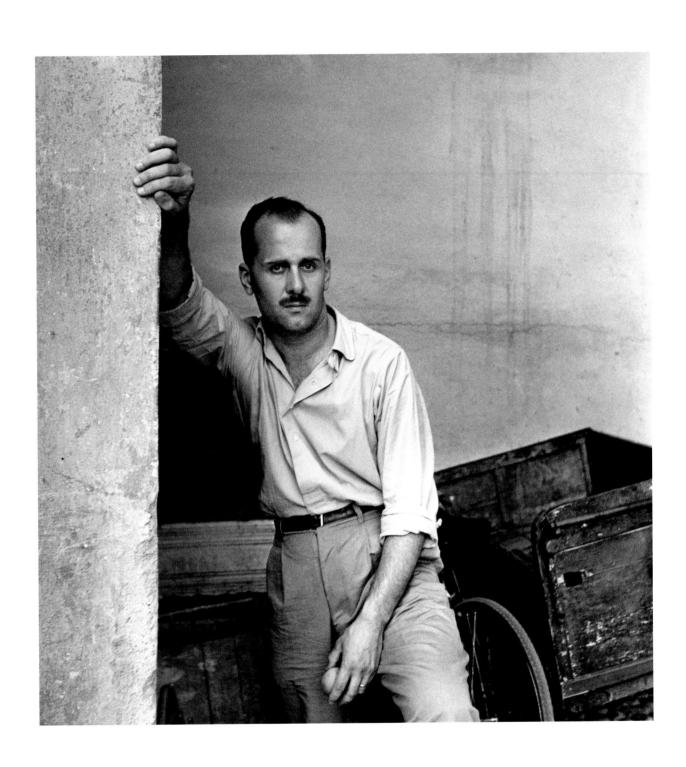

Piero Fornasetti, 1946

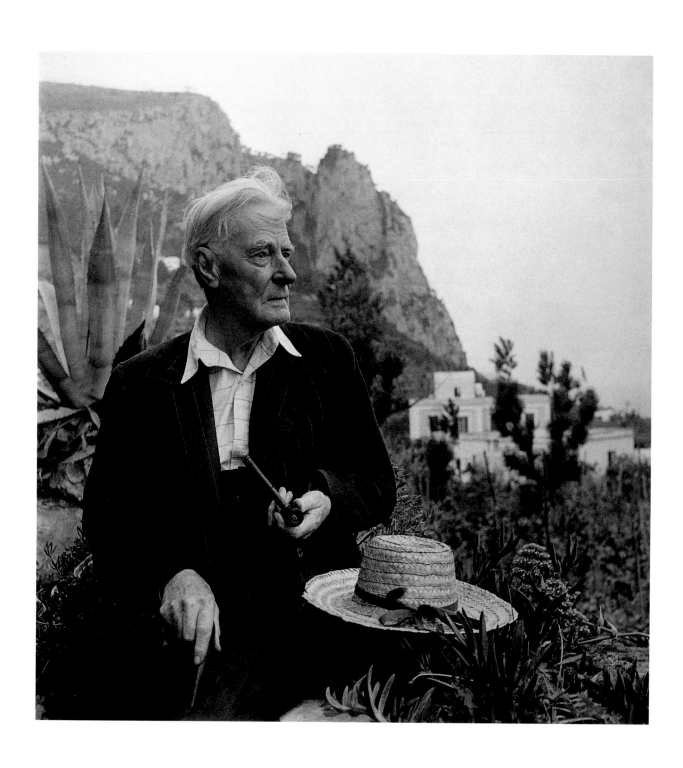

Norman Douglas, 1947

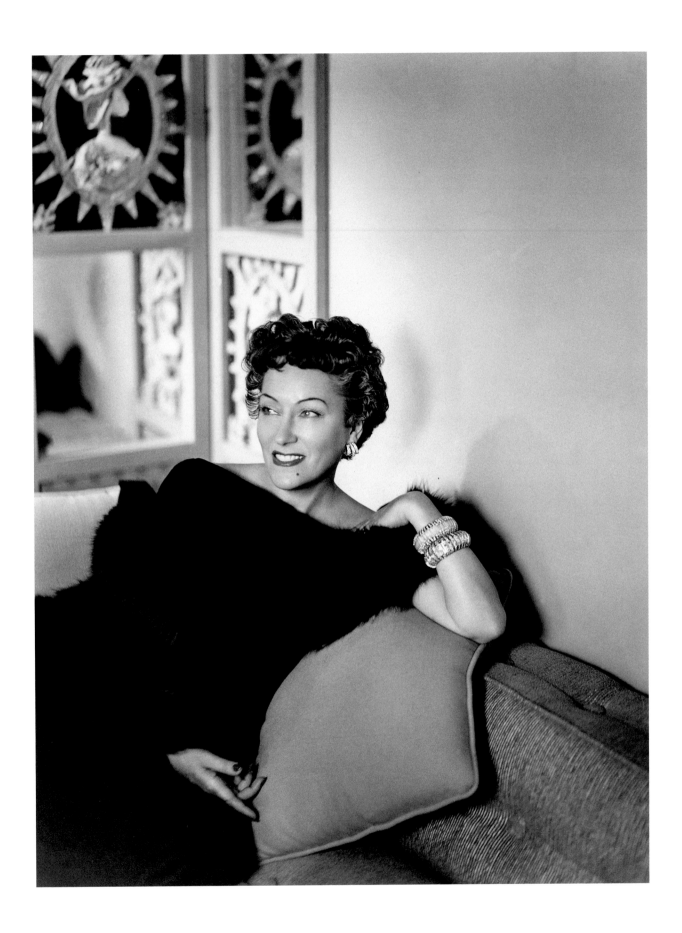

Gloria Swanson, 1949

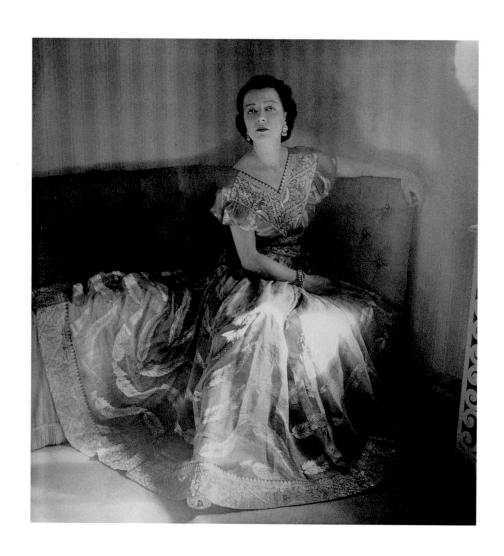

Mrs Sacheverell Sitwell, 1947

Princesse Jean de Polignac, 1950

Lady Diana Cooper, 1948

Anna Magnani, 1946

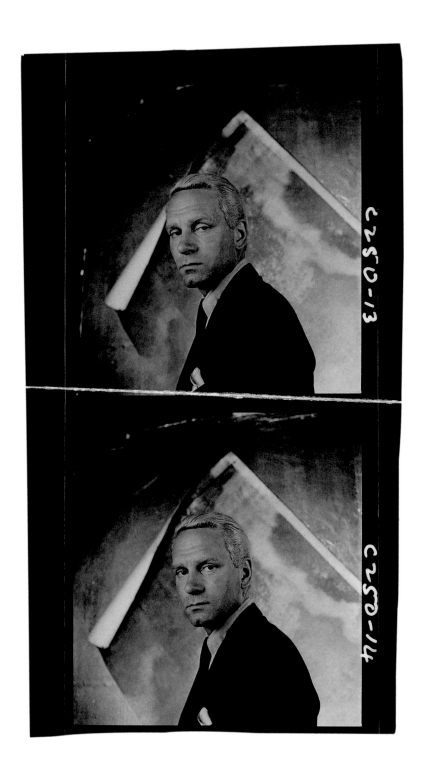

Laurence Olivier, 1947

Joy Parker, 1947

Peter Brook, 1946

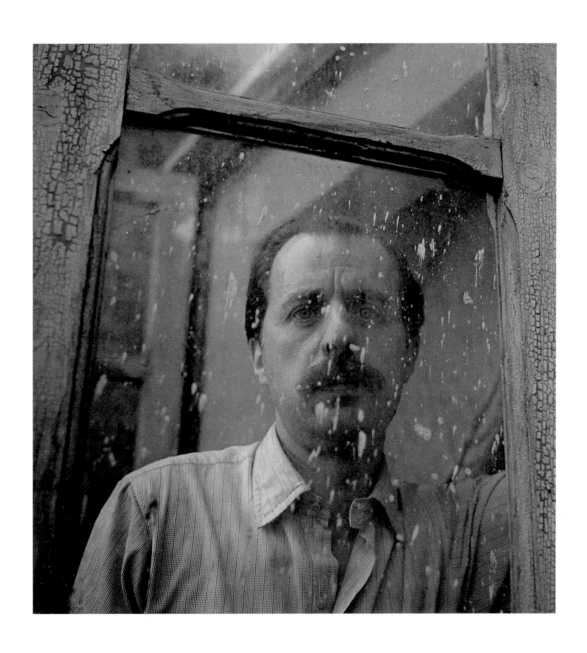

Franco Gentilini, 1946

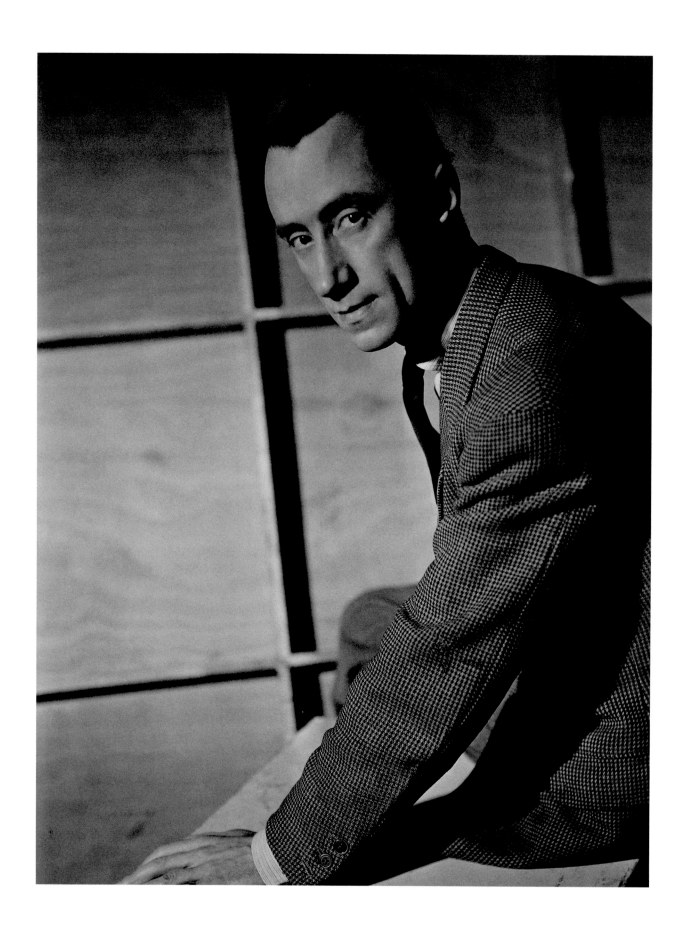

Eugène Rubin, 1946

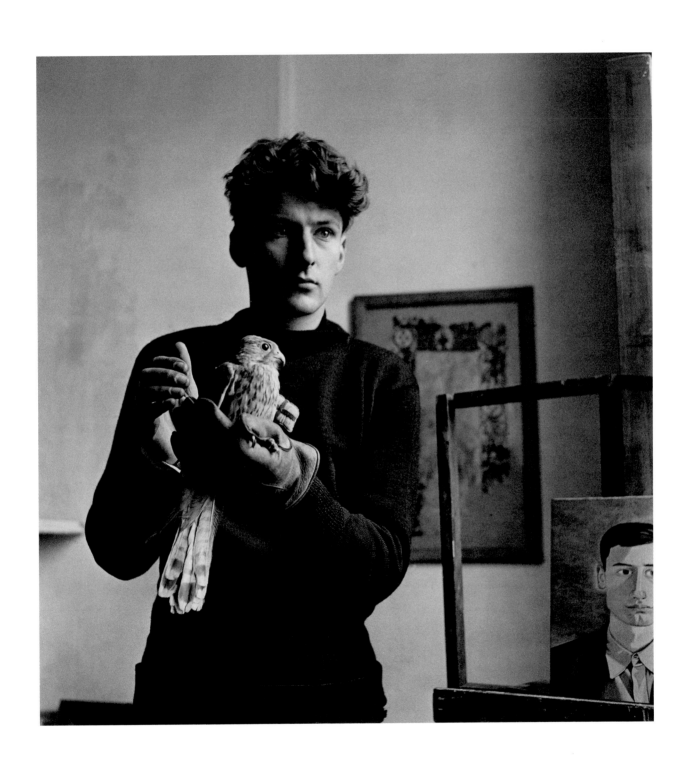

Lucian Freud, 1947

Mai Zetterling, 1948

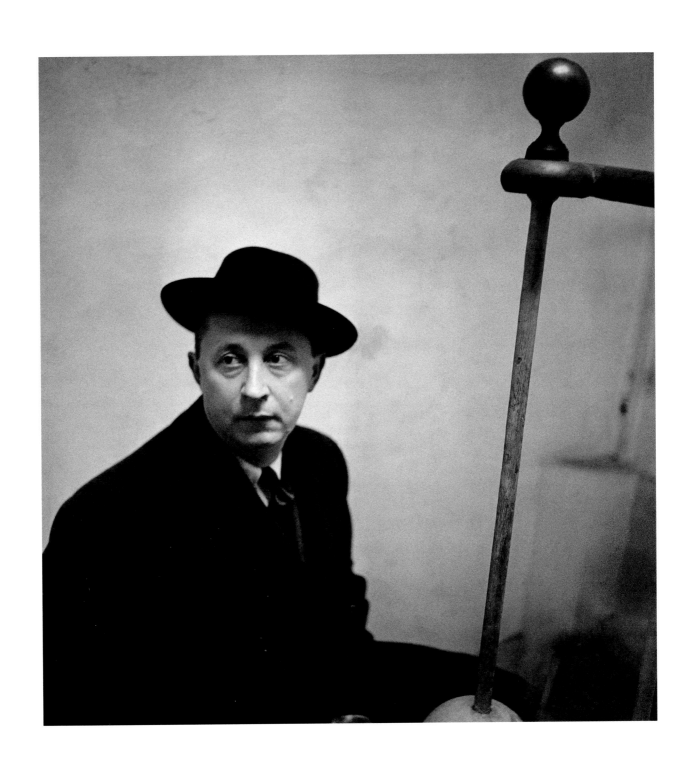

Christian Dior, 1947

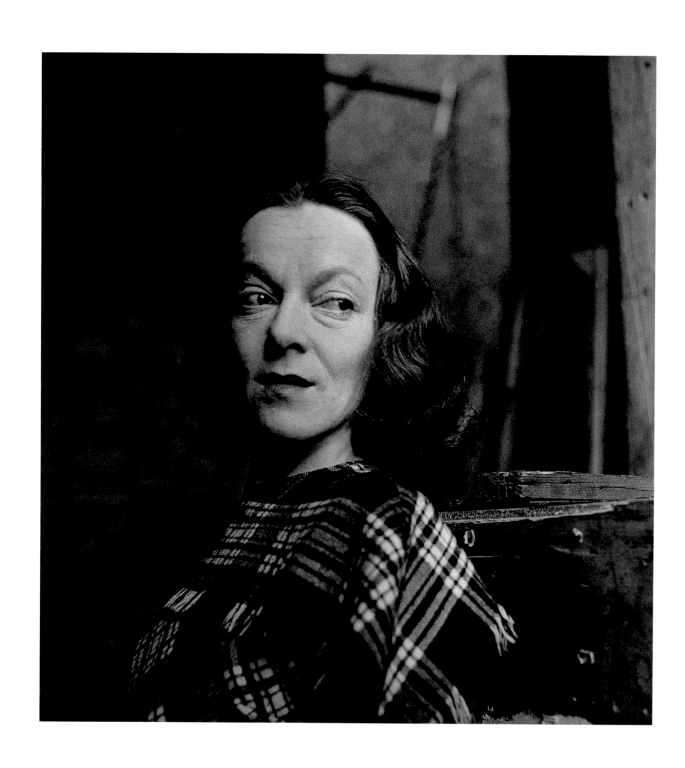

Beatrix Lehmann, 1947

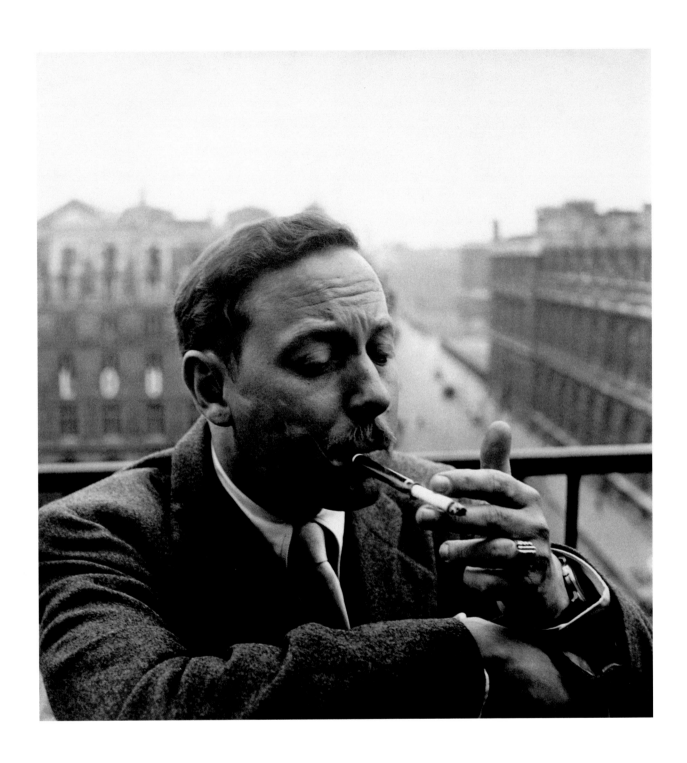

Tennessee Williams, 1948

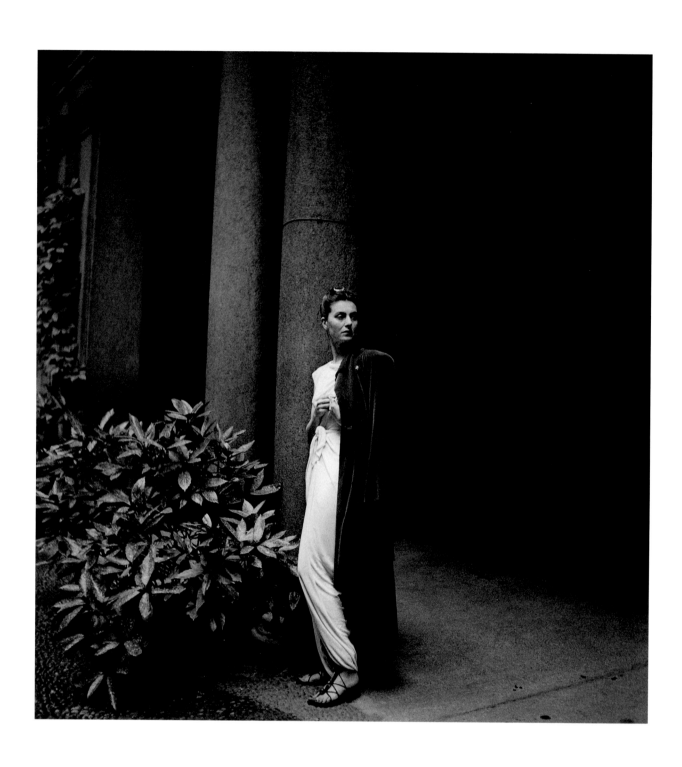

Countess Visconti, 1946

Celia Johnson, 1947

Louis Jouvet, 1948

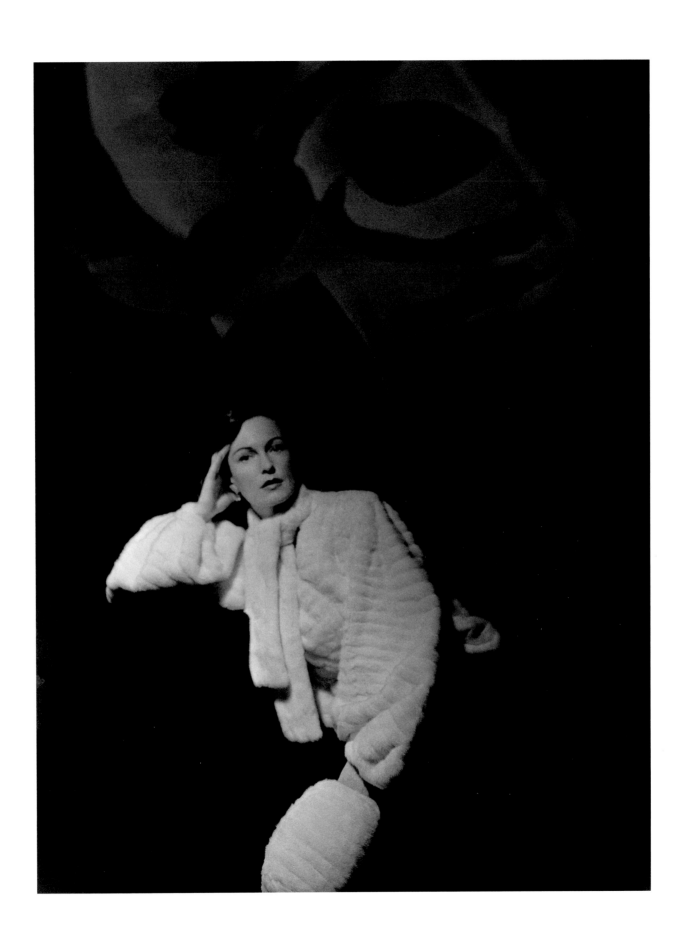

Geraldine Fitzgerald, 1947

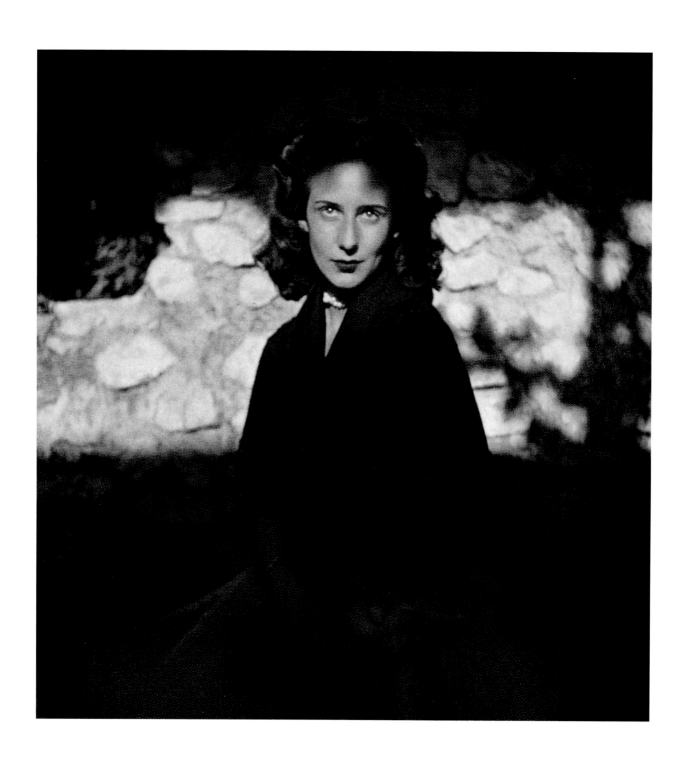

Princess Alessandro Ruspoli, 1948

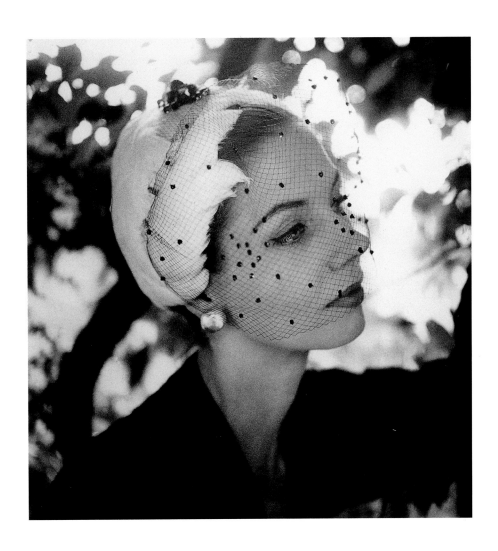

Enid Munnick, 1954

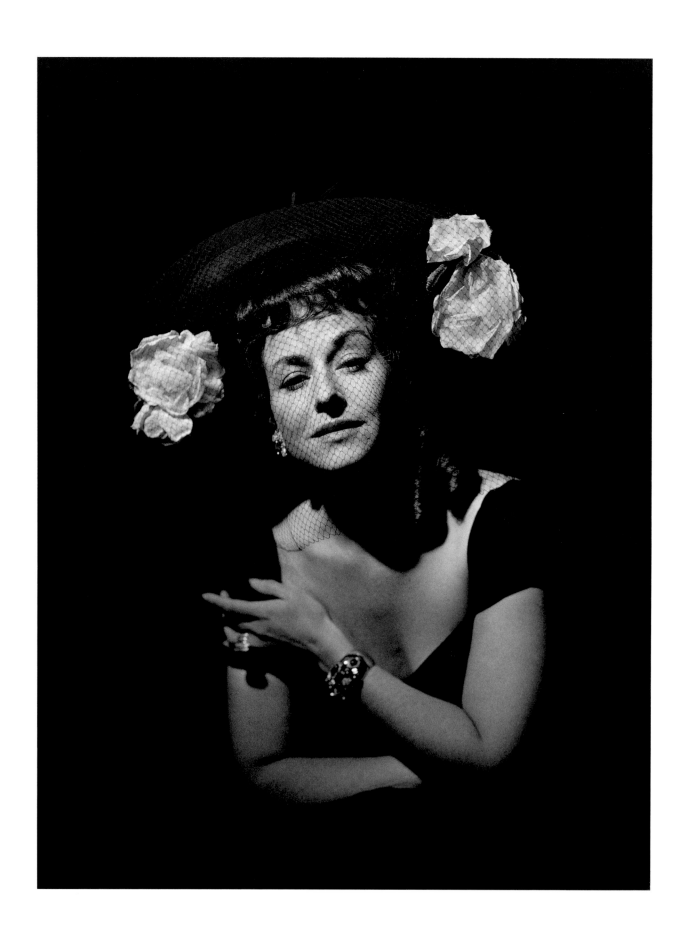

Paulette Goddard, 1947

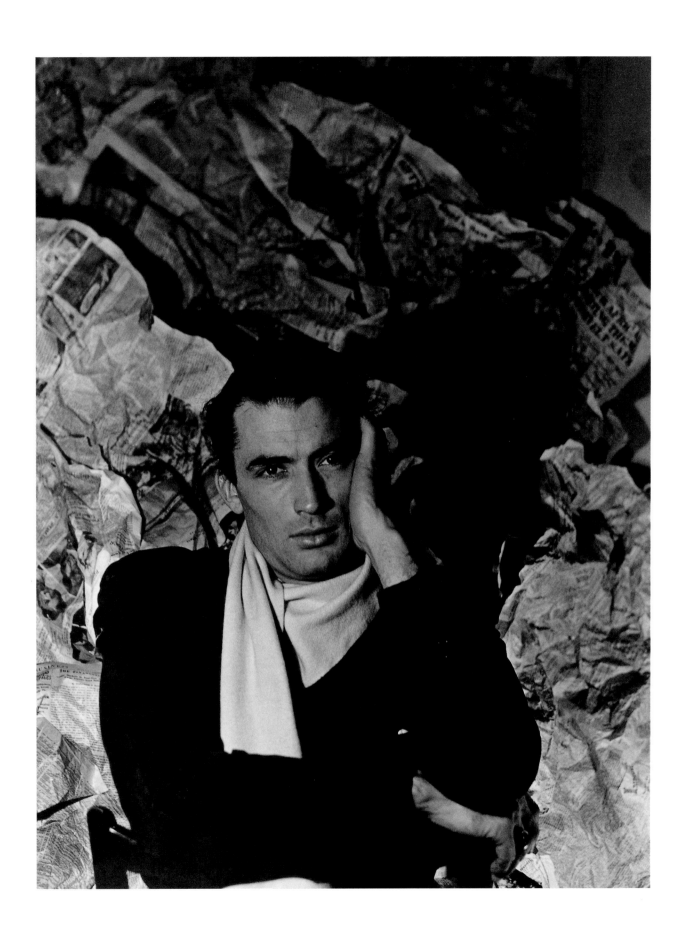

Gregory Peck, 1945

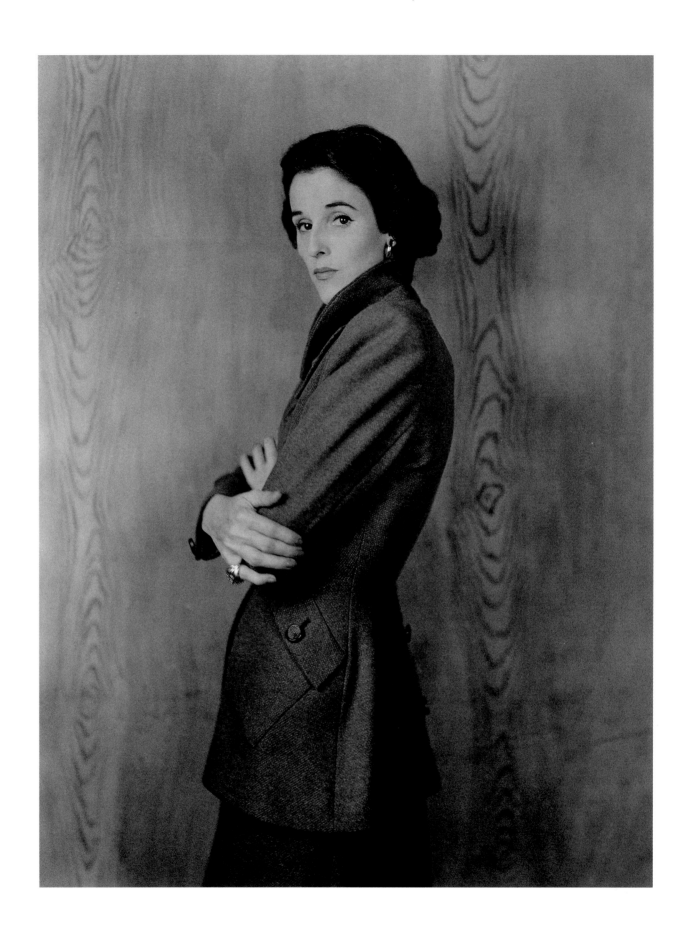

Mrs Stanley Grafton Mortimer Junior, 1946

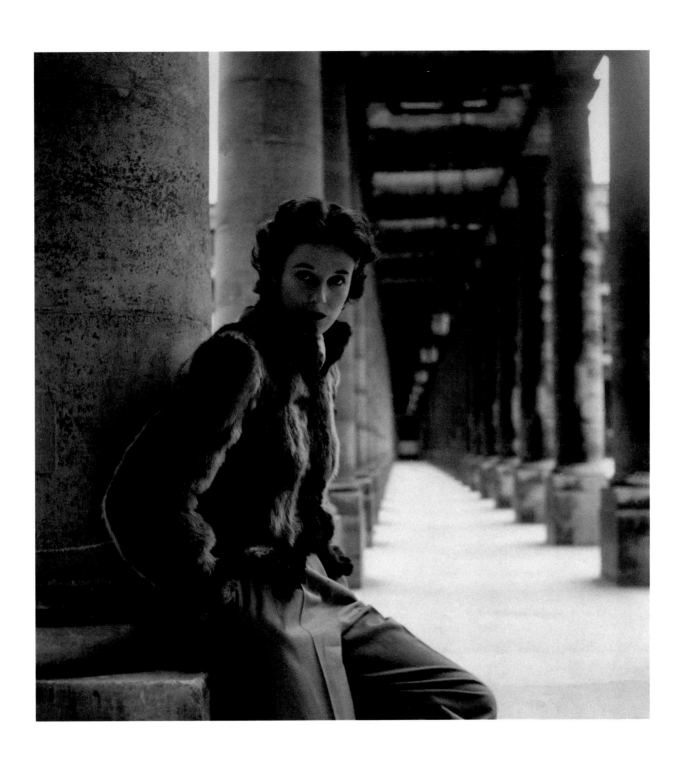

Mrs Stanley Grafton Mortimer Junior, 1946

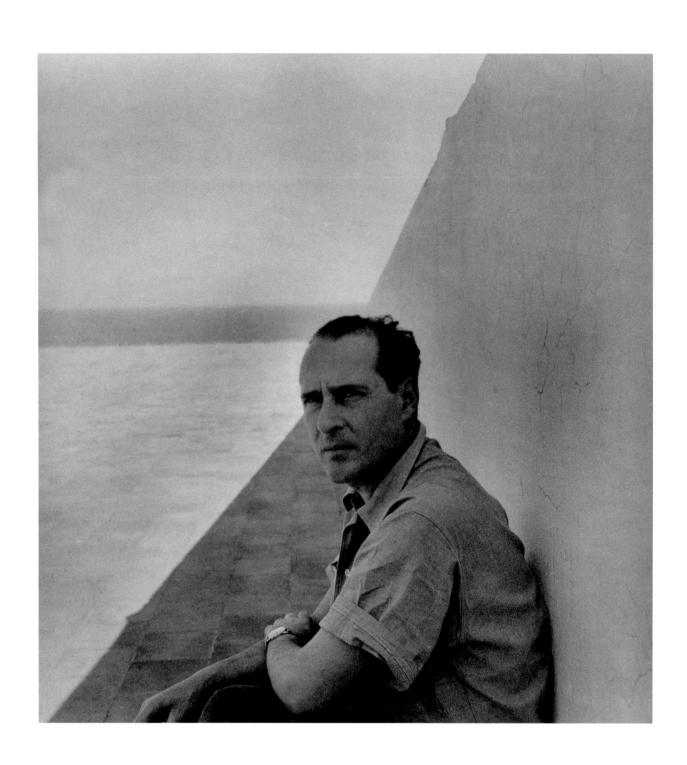

Roberto Rossellini, 1947

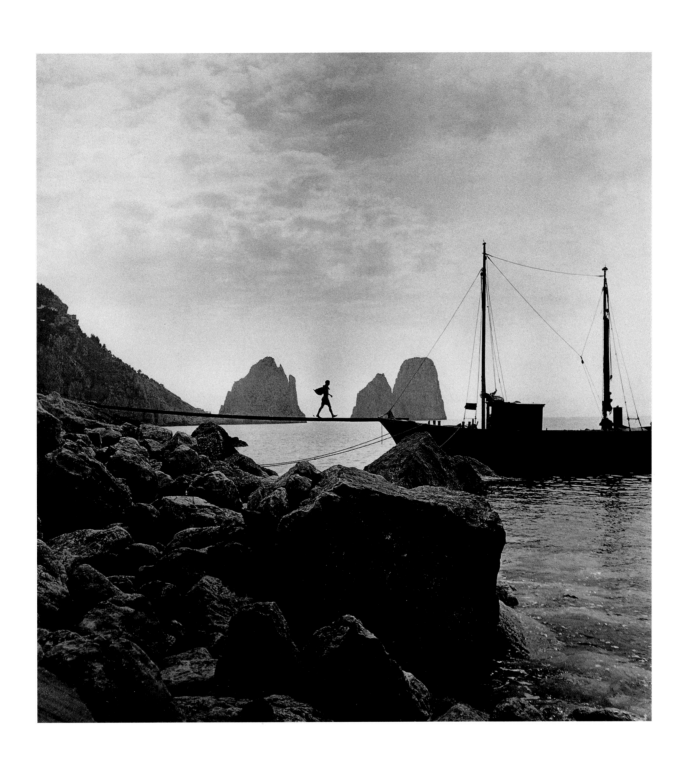

Capri, 1947

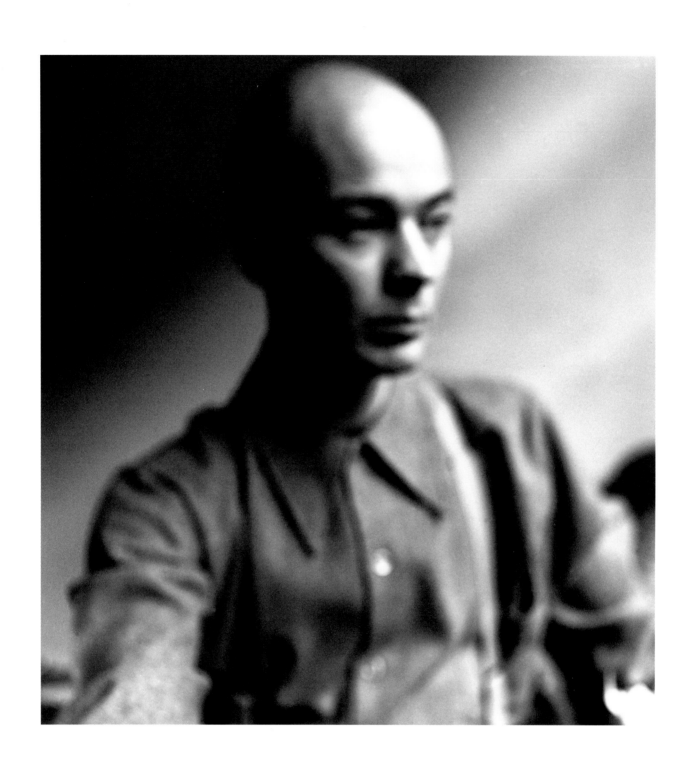

Clifford Coffin, c. 1946

list of plates

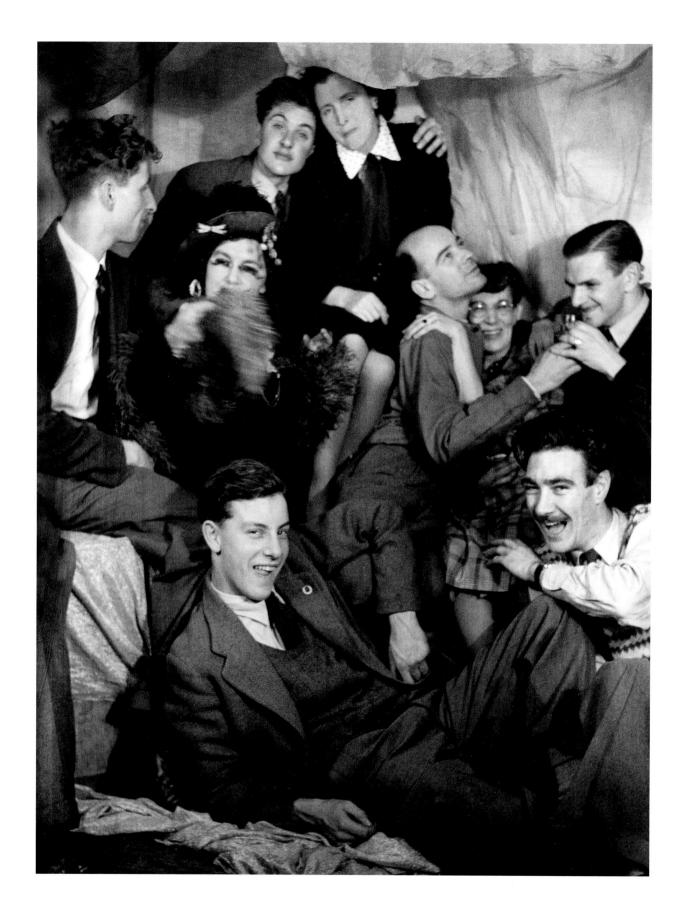

Clifford Coffin's christmas party
Vogue studio, London 1947.
Photographer unknown

Acknowledgements

Research for this book started over a decade ago
and I am grateful to Alex Kroll, former Editor of Condé Nast Books,
and Lothar Schirmer of Schirmer/Mosel for their
encouragement over the years.

Clifford Coffin's life is poorly documented but he appears to have left an impression,
good or bad, on many people. I am especially grateful to the following who found time to talk or write
to me about him and also to Bruce Knight who introduced me to many of them:

Unity Barnes; Rosamond Bernier; Peter Brook; Anne Chapman; Edmonde Charles-Roux;
the late Henry Clarke; Della Cooke; Rosemary Cooper; Patricia Creed; Ted Croner; Miki Denhof; the late Anthony
Denney; Catherine di Montezemolo; Vicomtesse d'Orthez; Simone Eyrard; Eileen Ford; the late Piero Fornasetti;
Tina Fredericks; Carolyn Garner; the late Liz Gibbons Hanson; Tom Hawkyard; Don Honeyman;
Horst; Buffie Johnson; William and Janine Klein; Joe Leombruno; Frances McLaughlin-Gill; Bettina McNulty;
William Margerin; the late Patrick Matthews; Despina Messinesi; Melanie Miller; Joan Morton; Lady Nutting;
the late Norman and Wenda Parkinson; Josephine Pletscher; Mary Jane Pool; Eugène Rubin; Mary Jane Russell;
Babs Simpson; Thelma Sweetingburgh; Lady Thorneycroft; Isobel Tisdall; Anne Valery; Gore Vidal;
the late Sheila Wetton; the late Denis Whelan; Ray Williams; and Audrey Withers.

I have received enormous help and support from Condé Nast Publications in London, New York
and Paris for which I am deeply grateful and would like to thank the following in particular:

Nicholas Coleridge, Emily Wheeler-Bennett and Harriet Wilson (The Condé Nast Publications Ltd.);
Lisa Brody, Nancy Kim and Darlene Maxwell (Condé Nast Library, London); Robin Derrick, Catherine Moore and
Stephen Quinn (British *Vogue*); Cindy Cathcart (Condé Nast Library, New York); Charlie Scheips (*Vogue* archives,
New York); Susan Train and Lucy Carrington (Paris Bureau, American *Vogue*); Lorraine Mead, Lisa Hellman and
Linda Rice (The Condé Nast Publications Inc.).

As ever I would like to thank Martin Harrison and Philippe Garner for their continued encouragement and
practical advice. Special thanks are due also to Lesley Cunliffe, Richard Holmes, Jane Rankin-Reid, Jane Ross
and Josephine Ross and, for their photographic skills, Terry Davies and Bob Wiskin of Grade One
and Clarissa Bruce.

At the National Portrait Gallery I was delighted to work with Christine Byron and Annabel Dalziel and
again with Kathleen Soriano, Robin Gibson, Sarah Kemp, Lisi Streule, Anna Dougherty and Terence Pepper.

I would also like to thank Julian Shuckburgh of Ebury Press and all at Schirmer/Mosel
and once again it has been a pleasure to work with Richard Smith of *Area*.

I am particularly grateful to Paul Lyon-Maris for his support and for editing the manuscript
and also to Lesley Cunliffe for her kindness over the years and the interest she has shown in this book.

Although there is still much to be said about Clifford Coffin
the introduction to this book would be immeasurably poorer without the
biographical detail supplied by Dwight Coffin. He never concealed anything, no matter
how private it might have been to the Coffin family, and for that I am very
grateful. I would, in turn, like to dedicate to him the text to this
book of his cousin's work.

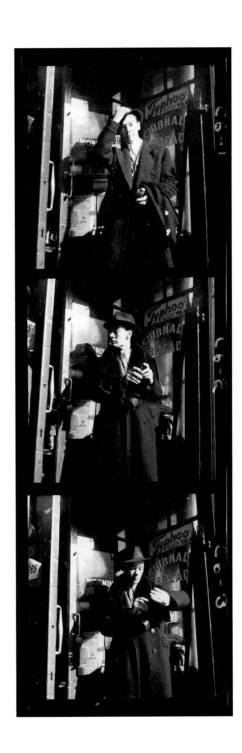

Clifford Coffin
London, 25 February 1946.
Unpublished contact strip.
Photographer unknown

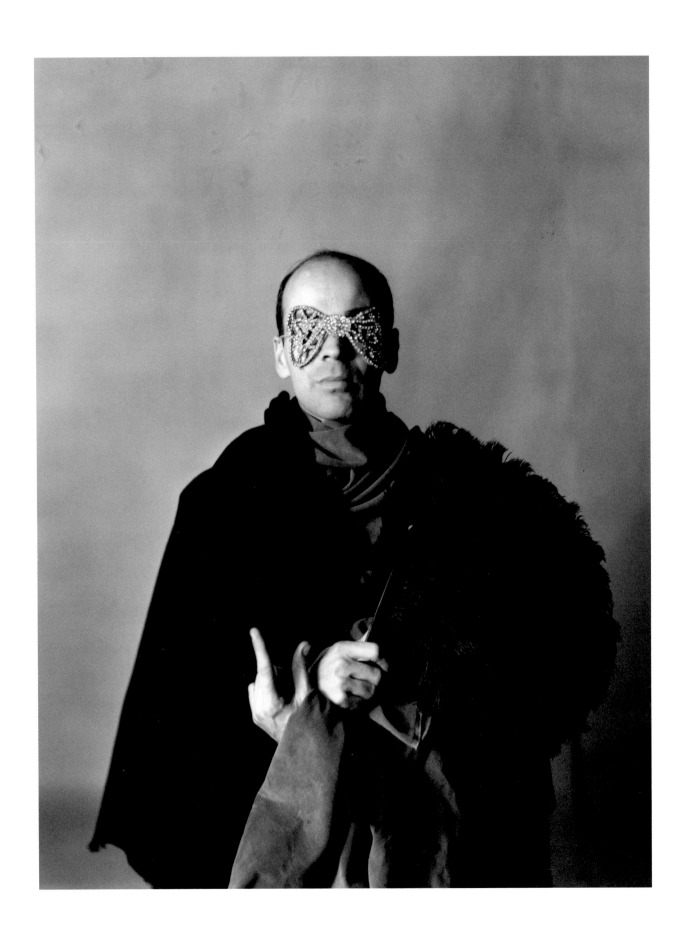